THE EAUTY OF INTIMACY

JANE HANSEN HOYT AND MARIE POWERS

Published by Gospel Light Ventura, California, U.S.A. www.gospellight.com Printed in the U.S.A.

All Scripture quotations, unless otherwise indicated, are taken from the New King James Version. Copyright © 1979, 1980, 1982 by Thomas Nelson, Inc. Publishers. Used by permission. All rights reserved.

Other versions used are

AMP—Scripture taken from THE AMPLIFIED BIBLE, Old Testament copyright © 1965, 1987 by the Zondervan Corporation. The Amplified New Testament copyright © 1958, 1987 by the Lockman Foundation. Used by permission.

ESV—Scripture taken from the English Standard Version, Copyright © 2001. The ESV and English Standard Version are trademarks of Good News Publishers.

KJV—King James Version. Authorized King James Version.

THE MESSAGE—Scripture taken from THE MESSAGE. Copyright © by Eugene H.
Peterson, 1993, 1994, 1995. Used by permission of NavPress Publishing Group.

NASB—Scripture taken from the New American Standard Bible, © 1960, 1962, 1963, 1968, 1971, 1972, 1973, 1975, 1977, 1995 by The Lockman Foundation. Used by permission.

NIV—Scripture taken from the Holy Bible, New International Version®.

Copyright © 1973, 1978, 1984, 2010 by International Bible Society. Used by permission of Zondervan Publishing House. All rights reserved.

Phillips—The New Testament in Modern English, Revised Edition, J. B. Phillips, Translator. © J. B. Phillips 1958, 1960, 1972. Used by permission of Macmillan Publishing Co., Inc., 866 Third Avenue, New York, NY 10022.

© 2011 Aglow International. All rights reserved. Previously published in 1998 in the Aglow Bible Study series as Fashioned for Intimacy.

Aglow International is an interdenominational organization of Christian women and men. Our mission is to lead the lost to Jesus Christ and provide opportunity for believers to grow in their faith and minister to others.

Our publications are used to help women and men find a personal relationship with Jesus Christ, to enhance growth in their Christian experience, and to help them recognize their roles and relationships according to Scripture. For more information about our organization, please write to Aglow International, P.O. Box 1749, Edmonds, WA 98020-1749, U.S.A., or call (425) 775-7282.

For ordering or information about the Aglow studies and other resources, visit the Aglow e-store at www.aglow.org.

Rights for publishing this book outside the U.S.A. or in non-English languages are administered by Gospel Light Worldwide, an international not-for-profit ministry. For additional information, please visit www.glww.org, email info@glww.org, or write to Gospel Light Worldwide, 1957 Eastman Avenue, Ventura, CA 93003, U.S.A.

To order copies of this book and other Gospel Light products in bulk quantities, please contact us at 1-800-446-7735.

Foreword	4
Introduction	5
How to Start and Lead a Small Group	9
1. The Father and His Family	11
2. A Tale of Two Trees	26
3. The Strike	42
4. Hidden Man of the Heart	58
5. Unmasking the Accuser	66
6. The Warrior Woman	85
7. A God of Purpose	94
8. I Will Not Go Without You	.109
The Beauty of Intimacy Leader's Guide	.117

When the apostle Paul poured out his heart in letters to the young churches in Asia, he was responding to his apostolic call to shepherd those tender flocks. They needed encouragement in their new life in Jesus. They needed solid doctrine. They needed truth from someone who had an intimate relationship with God and with them.

Did Paul know as he was writing that these simple letters would form the bulk of the New Testament? We can be confident that the Holy Spirit did! How like God to use Paul's relationship with these churches to cement His plan and purpose in their lives, and, generations later, in ours.

We in Aglow can relate to Paul's desire to bond those young churches together in the faith. After 1967, when Aglow fellowships began bubbling up across the United States and in other countries, they needed encouragement. They needed to know the fullness of who they were in Christ. They needed relationship. Like Paul, our desire to reach out and nurture from far away birthed a series of Bible studies that have fed thousands since 1973 when our first study, *Genesis*, was published. Our studies share heart to heart, giving Christians new insights about themselves and their relationship with and in God.

In 1998, God's generous nature provided us a rewarding new relationship with Gospel Light. Together we published our Aglow classics as well as a selection of exciting new studies. Gospel Light began as a publishing ministry much in the same way Aglow began publishing Bible studies. Henrietta Mears formed Gospel Light in response to requests from churches across America for the Sunday School materials she had written. Gospel Light remains a strong ministry-minded witness for the gospel around the world.

Our heart's desire is that these studies will continue to kindle the minds of women and men, touch their hearts, and refresh their spirits with the light and life a loving Savior abundantly supplies.

This study, *The Beauty of Intimacy*, explores God's original design for the relationships between men and women, and then moves into a discovery of His plan for reconciliation between men and women and Himself. I know its contents will reward you richly.

Jane Hansen Hoyt International President Aglow International

Jesus, Whom heaven must receive [and retain] until the time for the complete restoration of all that God spoke.

ACTS 3:20-21, AMP

Many things are being restored in our day. Perhaps most significant is the restoration of relationships in the Body of Christ. Sweeping movements of reconciliation are covering the land. God is moving by His Spirit today to reconcile races, cultures and denominations.

In our book Fashioned for Intimacy: Reconciling Men and Women to God's Original Design, Jane and I addressed the final front: healing the rupture within each race, culture and denomination—the division between male and female, the first relationship to be created, not only in individual couples but in the corporate Church as well.

The Holy Spirit is restoring our vision and opening our eyes as never before to see areas of prejudice and places we have hurt and wounded one another in every level of relationship. God is answering Jesus' final prayer for His Church, "that they all may be one . . . that the world may believe that You [the Father] sent Me" (John 17:21). The Holy Spirit is preparing the family of God for the return of Christ!

Though our introductory Scripture in Acts 3:20-21 indicates that all things will be restored prior to Jesus' release from heaven to return to earth, it does not mean that the earth and all the ills of the world will be restored and somehow miraculously made right. Isaiah 60:2 states that "darkness shall cover the earth, and deep darkness the people." Yet God brackets these words of foreboding with a marvelous prophecy to His people that will be happening at the same time: "Arise, shine," God tells His people, "For your light has come! And the glory of the LORD is risen upon you . . . the LORD will arise over you, and His glory will be seen upon you" (vv. 1-2).

In this day of wars and rumors of wars and ethnic group against ethnic group (see Matthew 24:6-7), as people clamor and jockey for position in this world, God is doing a work in His own people. As the world grows darker, the light of the glory of God's children will shine ever brighter as He restores His family to His original design.

This is what we see Him doing today. He is restoring His house—His dwelling place—that He might come and fill it with His glory. This house

is not made of brick or stone, but of "living stones" (1 Peter 2:5) being built into a spiritual house. It consists of men and women, flesh and blood, hearts made one with His.

From the beginning, God made known His intent: "So God created man[kind] in His own image . . . male and female He created them. Then God blessed them, and God said to them . . . 'fill the earth and subdue it; have dominion over [it]' " (Genesis 1:27-28). Thus was announced the beginning place, the foundation of the House of the Lord—the place where He would dwell. Male and female, man and woman, the fundamental union God specifically fashioned to vividly and accurately display His image, His heart and His character in the earth.

God's plan was not a secret. He had declared it publicly to the universe, and His archenemy had heard it. The enemy knew that the success of the plan depended on the unity and trust of these two people, for together they bore God's image. So once again, Satan endeavored to rise up against God and exalt his throne, his rule, above the throne of God. He knew right where to strike (see Isaiah 14:13-14).

Satan knew that it was essential to bring separation, distrust, fear and suspicion between male and female, the image-bearers that God had purposed to use for His unfolding plan on earth. The strength of man and woman was in their union. Without unity, without oneness, God's plan could not be achieved.

Satan struck, and his strategy worked. In shame, blame and distrust, Adam and Eve covered themselves from each other even before they hid from God. God's original design was broken, His image corrupted.

We know that the human race continues to suffer the fallout from Satan's malignant coup, but the sad truth is that the Church itself has not fully recovered from this catastrophic event. We in the Body of Christ have yet to experience a key and vital reconciliation—that between man and woman—and as a result, the work of God suffers great loss. This relationship, above all others, is the foundational place from which God will work to accomplish His ultimate intention.

In *The Beauty of Intimacy*, we explore what was truly in the heart of God as He brought forth that first man and woman and the factors that continue to militate against the fulfillment of all that He purposed to accomplish in and through their lives.

AN OVERVIEW OF THE STUDY

This Bible study is divided into four sections:

- 1. A Closer Look at the Problem defines the problem and the goal of the lesson.
- 2. A Closer Look at God's Truth gets you into God's Word. What does God have to say about the problem? How can you begin to apply God's Word as you work through each lesson?
- 3. A Closer Look at My Own Heart will help you clarify and further apply Bible truth in your own life. It will also give guidance as you work toward change.
- 4. Action Steps I Can Take Today is designed to help you concentrate on immediate steps of action.

This Bible study will enable you to explore the truths we first presented in *Fashioned for Intimacy* at a deeper, more comprehensive level. As you work through this study, you will gain a greater understanding of God's original design for His Church and how Satan's strike at the heart of God's design—male and female—continues to weaken and cripple marriage, family, the Church and society to this day. You will discover how this crippling is lived out in our relationships with God and with each other so that we are robbed of the intimacy God intended to satisfy both His heart and ours. You will also discover biblical truths that will again restore us to God's original design and empower us to fulfill our mandate of purpose in the earth.

WHAT YOU WILL NEED

- A Bible—The main Bible used in this study is the New King James Version, but you can use whatever Bible translation you are used to reading.
- A Notebook—During this study you will want to keep a journal to record what God shows you personally. You may also want to journal additional thoughts or feelings that come up as you go through the lessons. Some questions may require more space than is given in this study book.

• Time to Meditate—Only through meditation on what you're learning will you hear God's Word for you and begin to experience a heart knowledge, as well as a head knowledge, of the subject of intimacy. Give the Holy Spirit time to personalize His Word to your heart so that you can know what your response should be to the knowledge you are gaining.

Each chapter of this study guide contains commentary that summarizes the main emphases of the book *Fashioned for Intimacy*. For this reason, you might want to read the book before doing this study. Answers to most of the questions can be found in the book as well as in Scripture study, but all questions are meant to challenge, stimulate and draw out your thinking on these topics.

HOW TO START AND LEAD A SMALL GROUP

One key to leading a small group is to ask yourself, What would Jesus do and how would He do it? Jesus began His earthly ministry with a small group called the disciples, and the fact of His presence made wherever He was a safe place to be. Think of a small group as a safe place. It is a place that reflects God's heart and His hands. The way in which Jesus lived and worked with His disciples is a basic small-group model that we are able to draw both direction and nurture from.

Paul exhorted us to "walk in love, as Christ also has loved us and given Himself for us" (Ephesians 5:2, *NKJV*). We, as His earthly reflections, are privileged to walk in His footsteps, to help bind up the brokenhearted as He did or simply to listen with a compassionate heart. Whether you use this book as a Bible study, or as a focus point for a support group, a church group or a home group, walking in love means that we "bear one another's burdens" (Galatians 6:2, *NKJV*). The loving atmosphere provided by a small group can nourish, sustain and lift us up as nothing else can.

Jesus walked in love and spoke from an honest heart. In His endless well of compassion He never misplaced truth. Rather, He surrounded it with mercy. Those who left His presence felt good about themselves because Jesus used truth to point them in the right direction for their lives. When He spoke about the sinful woman who washed Jesus' feet with her tears and wiped them with her hair, He did not deny her sin. He said, "Her sins, which are many, are forgiven, for she loved much" (Luke 7:47, *NKJV*). That's honesty without condemnation.

Jesus was a model of servant leadership (see Mark 10:43-44). One of the key skills a group leader possesses is the ability to be an encourager of the group's members to grow spiritually. Keeping in personal contact with each member of the group, especially if one is absent, tells each one that he or she is important to the group. Other skills an effective group leader demonstrates include being a good listener, guiding the discussion, as well as guiding the group to deal with any conflicts that arise within it.

Whether you're a veteran or brand new to small-group leadership, virtually every group you lead will be different in personality and dynamic. The constant is the presence of Jesus Christ, and when He is at the group's center, everything else will come together.

You're invited!

To grow . . .

To develop and reach maturity; thrive; to spring up; come into existence from a source;

WITH A GROUP . . .

An assemblage of persons gathered or located together; a number of individuals considered together because of similarities;

TO EXPLORE . . .

To investigate systematically; examine; search into or range over for the purpose of discovery;

NEW TOPICS

Subject of discussion or conversation.

MEETING

Date		Time
Place		
- 19 - 19		
		8
Contact	the state of the s	and a filler suggested for the state of the same
Phone		

Note: Feel free to fill in and photocopy this as an invitation to hand out or post on your church bulletin board. © 2011 Gospel Light, *The Beauty of Intimacy*. Permission to photocopy granted.

THE FATHER AND HIS FAMILY

He also has planted eternity in men's hearts and minds [a divinely implanted sense of a purpose working through the ages which nothing under the sun but God alone can satisfy].

ECCLESIASTES 3:11, AMP

There is in each of us, whether we are Christians or not, a sense that life must have a purpose, that it must consist of more than mere survival skills—that it must be made up of more than climbing to the top of the ladder of success and the accumulation of money and goods to prove our worth and existence. Ecclesiastes 3:11 tells us that this sense of purpose comes from God. The passage also declares that only God Himself can satisfy it. Only God can reveal to our hearts what our purpose is, and only God can satisfy our deep longings for significance.

PART ONE: GOD'S DESIGN

God's plan and purpose for us have been carefully designed. He did not leave us to guess at what His plan is for our lives. Our goal in this chapter is to begin our discovery of God's clear design, what motivated that design, and what has threatened that plan from the beginning of time.

A Closer Look at the Problem

The central theme in God's plan for humanity on the earth was the concept of family. There is something innate within us that responds to family, because the Creator of the universe has marked our hearts with the need for love, belonging, unity, warmth and safety. All of these are the dynamics of a family as God designed it to be.

Never before in history has the family been so violently under siege. Not only are families falling apart at unprecedented rates, but also the very concept of family as we have known it is being attacked as outmoded and declared by many to no longer be of any practical value. Some are declaring that the conventional concept of family is hostile and discriminatory, and they have attempted to redefine "family." However, when the backbone of God's framework crumbles, all of life is thrown out of joint. Pain, disintegration, dysfunction and brokenness are the excruciating results.

What is some of the pain and dy	sfunction that society is suffering because
God's framework—the family—i	
	so surreining such great assuart.
18 17	8
ver! 1	
	people attempt to replace family when they
leave their own biological family	y?
W/1	
What are they looking for?	

The Church is not exempt from this onslaught of family breakdown. In fact, the difference in the divorce rate within the Church and without is negligible. Even if a family appears to be intact, it does not necessarily guarantee that love and caring are the dynamic of the home.

In Scripture, the term "house of God" is used to describe the "household" or "family" of God—the Church. First Peter 4:17 declares that "the time has come for judgment to begin at the house of God." First Corinthians 11:32 in the *Amplified* version reads, "But when we [fall short and] are judged by the Lord, we are disciplined and chastened, so that we may not [finally] be condemned [to eternal punishment along] with the world."

What do you think moves the heart of God to discipline His own people (see Hebrews 12:5-6)?
A Closer Look at God's Truth
FATHER: A RELATIONAL TERM
Do you tend to view the term "father" as biological or relational? What constitutes a "father"?
In our broken society today, we can easily forget that the word "father" in intended to be inherently relational. It identifies a type of relationship to someone. What do you think would be most significant to a loving father' heart? Would it be merely the number of children he would have, or would there be something more in his desire for a family?
Does this affect your viewpoint of God? If so, how?
4
Read Ephesians 1:3-6. What does this passage tell us was God's design for us from before the foundation of the world?
Note that the word "sons" (Greek <i>huios</i>) in Scripture, when referring to God people, is inclusive of male and female. "Sons" is an important term that do notes those who are heirs and who are moving toward maturity through the

nurture, training and discipline of the Holy Spirit. Such training is to prepare the sons—heirs—for the "receiving [of the] kingdom" (Hebrews 12:28) that has been "prepared for [them] from the foundation of the world" (Matthew 25:34). "Sons" is a term that denotes a full inheritance (see also Romans 8:14-17; Galatians 3:26-4:7; Hebrews 12 and Revelation 21:7).
Read Hebrews 2:9-10. How has God made every provision for His plan and purpose for us to come to complete fulfillment?
What does this tell us about the heart of God for His children?
FAMILY: AN OUTFLOW OF THE FATHER'S HEART God's most basic and fundamental nature is that of a Father. All of His creative work issued out of His Father-heart's desire for a family. Initially, He created a home for His future children, and when it was ready, He created the first members of His family, fashioned in His own image, to dwell in it. These two members, Adam and Eve, were then given the privilege of enlarging God's family as well as given stewardship over the earth. God commanded them to "be fruitful and multiply; fill the earth and subdue it; have dominion over the earth" (Genesis 1:28).
Read Ephesians 3:14-15 in several different translations. From whom does this passage tell us that the family derives its name? (Note that the word "name" in Scripture denotes "honor, authority or character.")
Which family is our earthly family intended to represent?

Why do you think God gave us this as a model?
THE FAMILY LINE The greatest revelations of the heart of God regarding family came in the person of His Son, Jesus—the One who came to earth to reveal the Father to us. Read Luke 2:51-52. What are we told happened to Jesus within the framework of family?
What does this say about God's confidence in His design of family?
Does this fact affect your viewpoint of family? If so, how?
THE FOUNDATION OF THE FAMILY The foundation of something is the beginning place. To verify the foundation of family, we have to go to the beginning. According to Genesis 1:27-28, who is the beginning or the foundation of the family?
This family was not just "a family." Whose image did they bear?

The Church is the New Testament name for the family, house or household of God. Read 1 Corinthians 3:11. Who is the foundation of the Church?
Only God Can Set Things Right Pastor Mike McIntosh of Grace Church in Federal Way, Washington, once noted, "So often we hear that the world is too intense, too violent, too ugly, and that is what is destroying our homes. It is not the world that is destroying our homes. It is the weakness of our homes that is destroying our world." Do you agree with these comments? Why or why not?
The health of society depends on the health of families. The health of families, however, depends on the health of the parents—how they function together as male and female. Male and female are the foundation of everything that God has planned to do in relation to His creation. Working together as God designed, they are the strength of society, family and the Church. One does not have to puzzle long to discover the roots of the problem of our fragmenting world. The failure to provide an environment for healthy and godly growth lies with us. Whether male or female, we are part of the problem.
At the beginning of time, God clearly spoke out His plan to have a family in His likeness who would represent Him on the earth. Satan also understood this plan, and he launched his attack at the heart of that plan. Who was the very heart of God's plan, and thus the target of Satan's attack?
Read Psalm 133. In this psalm, what are we told is a basis for God's blessing on a people?

If there is disunity, what can we conclude will be the res	sult?
Read Matthew 18:18-19; 1 Peter 3:7 and Malachi 2:13-1 respond to these Scriptures in light of Psalm 133?	6. How would you
In a word, what is the most critical quality of all relation with male and female?	onships, beginning
Because of this, what can we expect Satan to be constant are some ways we can see his activity played out?	tly doing, and what

A Closer Look at My Own Heart

God wants to heal the rupture in His Church. In the past, we have seen the Spirit move to bring greatly needed reconciliation on two important fronts: racially and denominationally. Now He is bringing us further. He wants to heal the division between male and female, the foundation of His house. Not only does He want to heal individual couples, but He also wants to heal the alienation and separation of male and female in the Church. God's design is a family for Himself, together forming a house in which He desires to dwell and express Himself in love and in power throughout the earth.

In what ways are you consistently or inconsistently (or both) living	ig your
life with the knowledge that you are part of God's larger family crea	
His pleasure and purpose?	icou ror
his picasure and purpose:	
The first of the second	
As you consider how essential unity and relationships are to the ment of His plan to restore His relationship with His people, wh	
tudes or behaviors in your life need to be reevaluated?	

Action Steps I Can Take Today

Write out Psalm 133 and place it where you can see it often this week.

Pray and ask God to reveal to you areas where you may have prejudices or attitudes that affect the way you relate to some members of the Body of Christ, God's family. Pay special attention to the areas of male/female roles and relationships.

If any come to mind, ask someone to pray with you for freedom. Remember, based on 1 John 1:7, if God reveals any wrong attitudes to you, He will be faithful to bring you to wholeness in these areas.

PART TWO: RESTORATION

In part 1, we noted that God's plan for His family is clearly stated in Scripture. Yet we see that the Church is far from His intended design. We should not be discouraged by this, however, for our confidence is based on the very nature of God Himself. He is a God of restoration.

In 1 Peter 4:19, we read that God is a "faithful Creator." This means that God did not just create humanity and then leave people to flounder and struggle to find their own way. Rather, He was faithful to bring them to His desired destination, if they would but trust Him. When Paul declared that he was "confident of this very thing, that He who has begun a good work in you will complete it until the day of Jesus Christ" (Philippians 1:6), he was not speaking of a new expression of God's love that began

with the advent of Jesus Christ. He was revealing the character and nature of God as it has always been: faithful to His creation.

God would complete and fulfill what He had started. The coming of Christ was the ultimate evidence of God's faithfulness. Jesus, the Creator of the universe, died to restore that which He had created. In this section, we will examine how God was faithful to restore what He had created and discover precisely what He was determined to restore.

A Closer Look at the Problem

Today we see little resemblance to the wonderful and perfect world that God created at the beginning of time. Because of the Fall, nature and humanity have suffered a deathblow, and we see the results all around us. The pristine beauty of nature as God designed it is now constantly at war with itself. Weeds, thorns, thistles, drought, disease and insects threaten to choke out God's beauty at every turn. It is a never-ending battle to keep gardens and fields free of these encroaching enemies in order to preserve some semblance of what we instinctively know is God's design for our world.

Humanity, too, is at war with itself. The lust, greed and covetousness that are at the root of the world's moral decay are predators that threaten to choke out the very life of the human race (see 2 Peter 1:4). Our hearts have become stained and marred and need to be replaced with new ones.

Read Jeremiah 13:23 and 17:9-10. What do these verses tell you about humanity's condition before God and about our ability to help ourselves?	
	-
Read Ezekiel 36:25-27. What is our only answer?	

A Closer Look at God's Truth

GOD'S HEART

Restoration is not just something on the heart of God; it *is* the heart of God. Restoration is the reason Jesus came to earth. Read Hebrews 4:3 and

	1	
How does Christ's death for ful Creator" (1 Peter 4:19)?	us demonstrate the natu	re of God as a "faith
Jesus died not only to redee	em us from the Fall but a	also to restore us to
Jesus died not only to redee God's original intention for		
	r us. Look up the word "	restore" in Webster's
God's original intention for	r us. Look up the word "	restore" in Webster's
God's original intention for	r us. Look up the word "	restore" in Webster's
God's original intention for Dictionary. What is the defin	r us. Look up the word " ition given for this word?	restore" in Webster':
God's original intention for Dictionary. What is the defin	r us. Look up the word " ition given for this word? esus was so that we would	restore" in Webster's
God's original intention for Dictionary. What is the defin	r us. Look up the word " ition given for this word? esus was so that we would wes—body, soul, spirit and	restore" in Webster's d receive restoration d purpose. Read Isa-

GOD'S REPRESENTATIVE

Although the full restoration of our bodies will not come until eternity, God's intention is that restoration of spirit, soul and purpose should begin in this lifetime. God wants to restore us to His image and likeness. In order for this to happen, however, we have to know what His image and likeness are. Jesus came to earth to demonstrate the nature of God as "the exact likeness of the unseen God" (Colossians 1:15, *AMP*), so that in beholding Him we could know the Father, what He is like, and be changed into His image (see 2 Corinthians 3:18).

Yet long before this happened, God wanted His people to know Him. A beautiful and poignant example of this is in Exodus 34:6-7, where God

tells Moses what He is like in His own words. In response to Moses' request to know Him, God declares that He will show Moses His glory by showing him His goodness (see Exodus 33:13,18-23).
Read Exodus 34:6-7. What are the character qualities that God declares about Himself?
Read Galatians 5:22-23, in which Paul describes the fruit of the Spirit. Note the similarities with the list that God gives concerning Himself. What is the purpose of the work of the Spirit in us?
CORPORATE HEADQUARTERS God's plan for redemption and restoration is not only individual but also corporate. In Matthew 5:18, Jesus says, "For truly I tell you, until the sky and earth pass away and perish, not one smallest letter nor one little hook will pass from the Law until all things [it foreshadows] are accomplished" (AMP). Read Matthew 22:36-40 and Romans 13:8. What is the fulfillment of the law?
Jesus came to do this: to fulfill the law. What single event in His life demonstrated both His total love for the Father and His immeasurable love for humanity (see Matthew 20:28; John 15:13)?
Read Romans 8:3-4. What do these verses say that Jesus came to do in us?

In Fashioned for Intimacy, Jane declares, "When Scripture states that the heavens will retain Him until all things have been restored, it is telling us that Jesus will not return for a Body that is still divided, weak and broken, a Body of people who blindly walk in darkness, oblivious to God's plan and purpose for them." The intent of the law was always to establish and maintain a people in right relationship with God and with each other (see Exodus 20:1-17). The law, however, could only govern their outward behavior
Referring to this statement, what is the main focus of God's restoring work?
Acts 3:21 states, "For the time being [Jesus] must remain out of sight in heaven until everything is restored to order again just the way God through the preaching of his holy prophets of old, said it would be" (<i>THE MESSAGE</i>). Notice that this verse is not referring to the whole world—it is referring to God's plan and purpose for His people. How will the world know when everything is restored to order in the Church and the law is fulfilled in us? What will they know? Why? (See John 13:34-35; 17:23.)
ALL MEANS ALL
Read Ephesians 1:11-12. What things do these verses tell us God works according to the counsel of His will? What is the end result of His working?
What can we know about the way God moves today based on the above verses of Scripture?

RESTORATION OF PURPOSE

Earlier, we asked what was of primary importance to God—what we are like or what we do. The answer is *what we are like*. We can only do what we have been created to do when our actions flow out of who we are as we are changed into God's likeness through the renewing of the Holy Spirit in our hearts. Yet God has designed us for purpose: "For we are His workmanship, created in Christ Jesus for good works, which God prepared beforehand that we should walk in them" (Ephesians 2:10).

In Genesis 1:28, we read what God created humanity to do. The <i>Theological Wordbook of the Old Testament</i> defines the word "fruitful" used in this verse as "to bear or bring forth fruit, to grow, to increase," and "multiply" as "to increase (in whatever respect), to bring up, enlarge, grow up." Based on these definitions, what do you see as a larger meaning than just increasing in numbers?
The <i>Theological Wordbook of the Old Testament</i> also states that the word "subdue" means "to make to serve, by force if necessary" and "assumes that the party being subdued is hostile to the subduer." Because plants and animals were in harmony with humans before the Fall, who would be the most likely force that would need to be subdued?
The "law of first mention" states that the first place something is mentioned in Scripture sets the groundwork for all further references to the same subject. According to this concept, what do the words "increase," "multiply" and "subdue" tell us about Adam and Eve's purpose?

This would have been a daunting task for the first couple—far too much for mere humans to accomplish. After all, according to Ezekiel 28:14, Satan

had been "the anointed cherub who covers," indicating his high office and his authority and responsibility to protect and defend the holy mountain of God. ⁵ There was a gaping inequality of power and experience between Satan and these two inaugural humans. Read 2 Corinthians 4:7 and 12:9. What clue do these verses give us that may explain how God would help them accomplish this task? (We will explore this further in subsequent chapters.)
Even before the Fall, God knew that evil would be a force for humankind to conquer.
A Closer Look at My Own Heart
As you contemplate the very nature of God's heart as a restoring God and His commitment to you as a "faithful Creator," are there areas in your life or circumstances that you have felt were beyond God's ability to restore? If so, what are those areas?
Do you ever feel that it's too late—that even though you are a Christian, you have ignored God's call to His complete Lordship too long and that He no longer has a significant purpose for you? Explain.
Perhaps there are loved ones in your life who have gone so far from God that you fear God may just wash His hands of them and no longer pursue them. How does the truth in this chapter affect your viewpoint?

Action Steps I Can Take Today

God wants to restore us to His image and likeness. However, in order for this to happen, we have to personally know Him. A person can be born again and still not really know the Father's heart. The main focus of God's desire is to restore us to relationship, first of all with Himself. As we come to know Him, we become more like Him—conformed to His image. Restoration to right relationship with ourselves and others, and restoration of purpose will flow out from there.

Read God's promise to you in Hebrews 8:8-12. These are God's words, His commitment to you. All who desire to know Him shall know Him. He delights to respond to you just as He did to Moses. He will tell you and demonstrate to your heart who He is and what He is like. This is His covenant to you that flows out of who He is—a restoring God who is in love with His children!

Is there anything holding you back from taking God at His Word in your life? If so, ask your heavenly Father to remove these obstacles. Make a commitment to allow Him to take away anything that blocks you from fully receiving His promises to you.

As you pray, remind yourself about things for which you are grateful to Him.

Notes

- James Strong, Strong's Exhaustive Concordance of the Bible (Grand Rapids, MI: Baker Book House, 1984), Hebrew #8034.
- 2. Jane Hansen Hoyt with Marie Powers, Fashioned for Intimacy (Ventura, CA: Regal, 1997), p. 32.
- R. Laird Harris, Gleason L. Archer Jr., and Bruce K. Waltke, eds., Theological Workbook of the Old Testament (Chicago: Moody Press, 1980), #2103, #2104.
- 4. Ibid., #951.
- 5. Jack Hayford, general editor, The Spirit-Filled Life Bible (Nashville, TN: Thomas Nelson, 1991), p. 1195.

HTALE OF TWO TREES

The tree of life was also in the midst of the garden, and the tree of the knowledge of good and evil.

GENESIS 2:9

From before the foundation of the earth, God had a mandate of purpose for His offspring, of which Adam and Eve were the beginning. They came into the world with work to do—a work of great magnitude. They were to "be fruitful and multiply; fill the earth and subdue it; have dominion over the fish of the sea, over the birds of the air, and over every living thing that moves on the earth" (Genesis 1:28).

Adam and Eve were created in the image and likeness of God. They were created with the capacity to be like God and represent Him in the earth as His stewards according to God's design and purpose. They were to fill the earth with the image and glory of God as they produced children who would also be in God's likeness.

PART ONE: THE NEED FOR THE LIFE OF GOD

We noted in the last chapter that Adam and Eve came into the world with an existing opponent who also wanted control of God's creation—a hostile adversary who would use all of his splendor and cunning wisdom to prevent them from accomplishing their task. This hostile force was Satan, the one who had challenged God in the heavenlies and would now challenge Him through His first created children on earth.

Part of Adam and Eve's training for "sonship" (attaining maturity and coming into their full inheritance) included learning to subdue and overcome this powerful adversary. This unbalanced situation—mere humans pitted again the most beautiful and powerful being ever created—was to be the "schoolroom" of their learning.

The goal of this first section is to discover the essential need for the life of God within the believer and the fact that this plan did not originate with the coming of Christ. Rather, it was God's design from the inception of His plan for a family. Everything God wanted to do in and through humanity hinged on the consummation of this event. We will also uncover the dangerous condition Adam was in when he ignored God's provision for him.

A Closer Look at the Problem
Let's begin by reviewing some of the qualities of Satan—whom Adam and Ever were to tread underfoot—so we can see just what they were up against. Read Ezekiel 28:11-19. In <i>The Spirit-Filled Life Bible</i> , Jack Hayford states that verses 14-15 "are the most conclusive evidence that this text likely refers to Satan's fall." What are some of the king of Tyre's qualities—remembering that we are looking at the king of Tyre as a personification, or type, of Satan?
What kind of being would it take to subdue this amazing creature?
A C1 I1 C12 T1
A Closer Look at God's Truth It would require beings of incredible power and wisdom to deal effectively with Satan. They would have to have superhuman and supernatural ability. In reality, only God Himself was wiser and more powerful than this creature, who was "the seal of perfection, full of wisdom and perfect in beauty" (Ezekiel 28:12). So what was the solution for Adam and Eve, who were so outclassed by their enemy?
GOD'S PROVISION Read Genesis 2:9,16-17. What were the two main trees in the Garden of Eden?

Read John 6:35,53-58. From these verses, what can we infer that the tree of life represents?
What can we infer the tree of the knowledge of good and evil represents?
In regard to the trees mentioned in Genesis 2:9,16-17, what was Adam commanded to do first?
Several sources say that Genesis 2:16 should be literally translated as follows: "And God commanded the man, saying, 'Of every tree of the garden eating you shall eat.' "2 The repetition of the word "eat" implies "superabundance" and intensifies the strength of the command. Given this, why was the first part of the command so important?
Notice that God first gives a positive command to Adam to partake of His provision before He gives a negative command to resist evil. How do we see this same pattern in Galatians 5:16, Ephesians 6:10-11 and James 4:7?

Jesus is the pattern Man, the "second Man" (1 Corinthians 15:47), who came to fulfill what the "first man" failed to do. Briefly review the story of the beginning of Jesus' ministry in Luke 3:21-23; 4:1-19. What event imme-

What was the significance of this order in Jesus' life, especially as it relates to His temptation in the wilderness and His ministry to the sick and the bound? Read John 5:19,30; 14:10. By whose life did Jesus live? We see that Jesus, even though He had been conceived by the Holy Spirit, needed a second impartation of the Spirit of God to begin and fulfill His ministry. We see this pattern in the lives of the first disciples as well. The disciples had received the Holy Spirit when Jesus breathed on them before His ascension. However, it was only after they obediently waited for and received the second impartation as the Spirit was poured forth from heaven that they became empowered to represent Him—to be His witnesses—in the	diately precedes the statement in verse 23: "Now Jesus Himself began Hiministry at about thirty years of age"?
We see that Jesus, even though He had been conceived by the Holy Spirit, needed a second impartation of the Spirit of God to begin and fulfill His ministry. We see this pattern in the lives of the first disciples as well. The disciples had received the Holy Spirit when Jesus breathed on them before His ascension. However, it was only after they obediently waited for and received the second impartation as the Spirit was poured forth from heaven that they became empowered to represent Him—to be His witnesses—in the	
needed a second impartation of the Spirit of God to begin and fulfill His ministry. We see this pattern in the lives of the first disciples as well. The disciples had received the Holy Spirit when Jesus breathed on them before His ascension. However, it was only after they obediently waited for and received the second impartation as the Spirit was poured forth from heaven that they became empowered to represent Him—to be His witnesses—in the	Read John 5:19,30; 14:10. By whose life did Jesus live?
works" through the empowerment of the Holy Spirit (see John 14:10-18). Read John 20:22, which was spoken to the disciples by Jesus after He rose from the dead, and Acts 1:4,8. How do these two passages affirm the pattern of two impartations?	needed a second impartation of the Spirit of God to begin and fulfill Hi ministry. We see this pattern in the lives of the first disciples as well. The disciples had received the Holy Spirit when Jesus breathed on them before Hi ascension. However, it was only after they obediently waited for and received the second impartation as the Spirit was poured forth from heaver that they became empowered to represent Him—to be His witnesses—in the earth. They would do the works that Jesus did, and they would do "greate works" through the empowerment of the Holy Spirit (see John 14:10-18). Read John 20:22, which was spoken to the disciples by Jesus after He rose from the dead, and Acts 1:4,8. How do these two passages affirm the pat

The same was true for Adam. Even though Adam had become a living soul when God breathed on him (see Genesis 2:7), he needed more to fulfill the calling of God on his life. As DeVern Fromke noted in *The Ultimate Intention*, "Perhaps nothing has so blighted the vision and growth of believers

as the false assumption that Adam in his innocence and sinlessness was all that God ever purposed him to be."³

God's provision for Adam was a further impartation of His own life, represented by the tree of life, of which Adam had to voluntarily partake. So essential was Adam's choice to eat that his life depended on it. The future of God's plan depended on it. Authority over the enemy depended on it.

Read Genesis 3:22. Because Adam would have lived forever had he eaten from the tree of life after he had sinned, what would have happened to
him if he had partaken of it before he sinned?
Did Adam live forever? From this, what can we conclude was Adam's response to the tree of life? Did he <i>ever</i> eat of it?
The life that God was offering to Adam was eternal life, which overcomes all things. It would have provided him with everything he needed for "life and godliness" (2 Peter 1:3). It could not have been snuffed out by death. However, we can deduce from Genesis 3:22 that Adam never partook of this life. Because Adam was not partaking of the tree of life as his source
of life, what life was he depending on?

In the beginning, Adam's neglect of the tree of life did not appear to be an evil thing. Of course, the activity of the flesh—life that issues from the self-center—does not always immediately appear evil. In *The Messenger of the Cross*, Watchman Nee notes, "In every sin we can see 'self' at work. Although people today classify sins into an untold number of categories, yet inductively speaking there is but one basic sin: all the thoughts and deeds which are sins are related to 'self.' "4

As human beings, we have three main enemies: (1) the world, (2) the flesh (self), and (3) the devil. Which of these three is the most dangerous? Why
Read James 1:14-15. How does verse 14 affirm the truth that self is our greatest enemy?
In Romans 5:19, Paul writes, "For just as by one man's disobedience (failing to hear, heedlessness, and carelessness) the many were constituted sinners" (<i>AMP</i>). What does this verse tell us about Adam's attitude toward God's provision for him?
W.E. Vine states, "Carelessness in attitude is the precursor (forerunner) of actual disobedience." What was Adam being careless about before he actually sinned?
In Romans 5:19, Paul writes, "For just as by one man's disobedience (failing to hear, heedlessness, and carelessness) the many were constituted sinners" (<i>AMP</i>). What does this verse tell us about Adam's attitude toward God's provision for him? W.E. Vine states, "Carelessness in attitude is the precursor (forerunner) of actual disobedience." What was Adam being careless about before he actual

Alone Is Not Good

Adam's position was precarious. He was on the brink of disaster. The story of the prodigal son and the father's heart describes for us the depth of love in the heart of the heavenly Father for His first created son. Knowing the catastrophic results if Adam chose to go his own way, He would do everything He could to help him before it was too late.

To fully appreciate Adam's situation, we must consider the words that are used as God speaks of him. Immediately after Adam is commanded in Genesis 2:16-17 to eat abundantly and freely of all the trees provided for his sustenance (which included the tree of life and excluded the tree of the knowledge of good and evil), God declares, "It is not good that the man

should be alone; I will make him an help meet [suitable] for him" (verse 18,
KJV). "Alone" is the key word here. Literally, it means "separation."

at this point, only God and the animals were present in Adam's life. Thoug adam had not yet sinned, he was not advancing in the way that he should	ould.
Ie was yet separated. In what way was he "separated" relationally from Goo	1?
	_
n Genesis 2:18, God says, "It is not good that man should be alone; I what him a helper comparable to him." What is the difference between the comparable to him."	
eing "alone" and "lonely"?	- 1

Dependence on our own life and strength must be seen as futile. We must renounce it, turn from it and deny it. In this first section, we have seen how critical this truth was for Adam. In order for him to fulfill his calling, he was required to deny his own life (even though it was not yet marred by sin) and be abundantly filled with the life of God. We see that Jesus followed this same pattern. Although He was sinless, He denied His own life and lived wholly by the life of the Father.

A Closer Look at My Own Heart

Even though we have been justified—"just-as-if-I'd-never-sinned," restoring
us to a condition similar to that of Adam before the Fall-and born again,
we can still be living our life out of our own strength. Considering the
truths we have studied in this section, can you say that you have left your
self-dependence behind? Why or why not?
The second secon

Do you still, for the most part, live your life by the tree of the knowledge of good and evil? That is, do you govern your life by setting up standards

or rules you have established by determining what is good and what is evil?
Do you try to do good and please God in your own strength?
2 c / c u c c / c u c g c c u u u u p - c u c c u c u - c u c u c u c u g c u c u c u c u c u c
Have you learned how to partake of Jesus through His Word, have fellow-
ship with the Father, and be changed from the inside so that the life of the
Spirit is the spontaneous result of your fellowship? If not, what is prevent-
ing you from doing this?

Action Steps I Can Take Today

Take your thoughts before the Father in Jesus' name. Tell Him that you know He created you to have fellowship with Him and represent Him in the earth. Tell Him that you understand that you can only do this by His life in you. Ask Him to give you discernment and a greater revelation of how to live by His life and not your own.

If you are not sure that you have received the full provision of God through the baptism of the Holy Spirit, ask someone to pray with you for this essential blessing and equipping by the Father. He will be faithful to answer these prayers, for "this is the confidence that we have in Him, that if we ask anything according to His will, He hears us. And if we know that He hears us, whatever we ask, we know that we have the petitions that we have asked of Him" (1 John 5:14-15).

Find someone who understands the truth of "walking by the Spirit," living by the life of Christ within, who can encourage you and strengthen you in your quest.

PART TWO: SHE SHALL BE CALLED WOMAN

As we begin this section, there is a problem in paradise. Until this time, God had pronounced all of His works to be "good." Now, for the first time, we hear God saying that something is *not good*: "It is not good that man should be alone" (Genesis 2:18). A solution was needed. That solution, in God's creative wisdom, would be woman.

The goal of this section is to illuminate the bringing forth of the woman and understand that God designed her specifically in answer to what He was observing. We want to discover what her purpose is, for when we know her purpose, we will then begin to understand who she is and what she will be like.

A Closer Look at the Problem

In the previous section, we left Adam in a precarious condition. God had commanded him to eat abundantly and freely of the trees in the garden—most particularly the tree of life, which represented the provision of God's life for Adam. Adam had to partake of this tree volitionally (by his own choice and action).

The fruit of the tree of life was absolutely essential to Adam. Without it, he would be vulnerable to the voice of the enemy and weak in resisting the desires of his own flesh. Eventually, this neglect would lead him to overt sin and rebellion against God. Adam, however, was ignoring God's provision. He was being careless and heedless toward God's positive command "to eat."

Read Genesis 2:15-18. To what situation was God speaking when He declared, "It is not good that the man should be alone; I will make him an
help meet [suitable] for him" (verse 18, KJV)? For what would the woman
be designed to be a help?
What kind of help would solve Adam's leaning toward isolation and independence?

A Closer Look at God's Truth

HIS OTHER SELF

Genesis 2:21-22 tells us that "[God] took one of [Adam's] ribs, and closed up the flesh in its place. Then the rib which the LORD God had taken from man

He made into a woman, and He brought her to the man." These verses represent the only time the Hebrew word <i>sela</i> is translated as "rib." This word is used many times in Scripture as "side" or "side chamber" and is generally an architectural term, referring to the side of an object. When God created the woman by taking a rib, He took a sizable portion of Adam's side. 6
What are your thoughts as you meditate on the meaning of this word?
Read Genesis 2:23. Adam recognized Eve as "bone of my bones and flesh of my flesh." Who was he saying she was?
Marvin Vincent translates Paul's words in Ephesians 5:28,33 as follows: "So husbands ought to love their own wives since they are their own bodies. He who loves his wife loves himself Nevertheless let each one of you in particular so love his wife as being his very self." Based on this, what are these verses in Genesis telling us?
Read Genesis 1:27. What was the two-step process of the creation of man?
First, Adam was created ("so God created man in His own image"), and then the woman was differentiated out of him ("male and female He created them"). When the woman was taken out of the man, the image of God was divided. Given this, how would that image be made full again?

The taking of Adam's bride out of his side was a foreshadowing of another event that was to come. What was it (see Ephesians 5:29-31)?
What does this tell us about God's value and perspective on marriage?
LEAVE AND CLEAVE When the woman was brought forth, something of Adam's own self was removed from him and returned to him in a very different package. Adam saw this and declared, "This is now bone of my bones and flesh of my flesh; she shall be called Woman because she was taken out of Man" (Genesis 2:23). No sooner had God performed His divine surgery, however, than He immediately gave Adam an instruction. Because Adam had recognized who the woman was—part of his own self—God gave him a directive that was a statement about how He intended Adam to relate to this gift.
Read Genesis 2:24, remembering that it directly follows Adam's statement. To what does "therefore" refer, and why is the man to cleave to his wife?
What does verse 24 tell us will happen when the man cleaves to his wife? What did they begin as?
Who is told to do the cleaving (notwithstanding the vows in many marriage ceremonies)?

When the woman was taken out of the man, he was no longer the same as before. Part of him was missing. So what happens when a man cleaves to
his wife?
,
What characteristics or qualities does a man receive back to himself when he cleaves to his wife?
The Hebrew word for "cleave" is <i>dabaq</i> , which means "to cling, stick to, follow closely, or join to." Webster's defines the meaning of "cleave" as "adhering to, to be faithful," which implies a sense of commitment. Given these definitions, do you think this cleaving to be merely a sexual joining, or was there a deeper meaning to the instruction? What did God have in mind?
HELP IN TIME OF TROUBLE Before the woman is called "woman" in the account of creation in Genesis 2, she is called a "help." "Help" (ezer in Hebrew) means "to surround, to protect, to aid, succor." What does this word tell us about Adam's condition?
What does this word tell us about the seriousness of the gift that God was giving to the man?

"Help" or <i>ezer</i> is an extremely strong word that is used 21 times in Scripture. It is used 16 times to refer to divine help from God Himself, and five times to refer to human help. In what ways did Eve represent <i>both</i> human
help and divine help?
,
FACE TO FACE
What are some of the beliefs you have held concerning the role of women and how they are to be a help to men? (Some of these beliefs may be of your own construction, or they may have been taught to you.)
3.43. 3.43.
So many of our viewpoints are self-relating. We tend to interpret things according to how they relate to us as human beings, often from our own understanding of "good and evil." God, however, always wants to move us from a human-centered or self-centered viewpoint to His perspective—how all things are properly related to Him. Let's look at some word meanings that describe from God's perspective the kind of help the woman would be—the kind of help He deemed to be the solution to a dangerous situation.
When God said, "I will make him an help meet for him," it is actually the word "for" that is the key. Dr. Karl Coke, a Hebrew scholar, wrote that nagad conveys the meaning "to the front, to the face, or actually 'face to face.' "It means to "stand boldly out opposite." Dr. Coke declares that this word literally means that the woman was to stand "toe to toe, knee to knee, waist to wait, chest to chest, nose to nose, and eyeball to eyeball" with her husband. How does this change your perception of what is being said in this verse?

What was God saying about His design of the woman? What was He creating her to be for the man's sake?
How might this affect the man's aloneness?
What are some words that come to mind when you think of being face to face with someone?
The name given to the woman—"Eve"—is taken from a Hebrew word that also denotes verbal communication. Women, in general, would be different from men in their ability to communicate, especially as it relates to their inner person. How does this confirm what God is telling us in Genesis about woman as a helper?
Note that in the Bible the word for "help" in the Hebrew literally means "to surround and protect." The woman was physically weaker than the man, so this could not refer to physical protection. What other type of help could the woman give?

How might the truths we have discussed in this chapter be applied beyond individual couples to the corporate Church?
A Closer Look at My Own Heart
King Lemuel's mother, who understood the purpose of women, counseled her son as follows:
An excellent [virtuous] wife, who can find? For her worth is far above jewels. The heart of her husband trusts in her, and he will have no lack of gain. She does him good and not evil all the days of her life (Proverbs 31:10-12, <i>NASB</i>).
If you are a man, how does what you have learned today correspond with your attitudes and feelings toward women? (If you are married, consider this question first and foremost in relation to your wife.)
<u> Partina de la composición del composición de la composición de la composición de la composición del composición de la </u>
Are there some adjustments in your thinking that you need to make? If so, what are they?
If you are a woman, how does what you have learned today correspond to your beliefs about yourself as a woman?

Does the way you relate to men (particularly your husband, if you are mar ried) correspond to what you have learned today?
Do some adjustments in your thinking need to be made? If so, what adjustments need to be made?

Action Steps I Can Take Today

In this chapter, you have seen how the design and bringing forth of the woman was a deliberate and precise act of God for a definite purpose.

Pray and ask the Lord, the One who created you, to give you a fuller revelation of His design and purpose for women and how men and women can together become one (as in the whole expression of humanity as God designed for us).

Write down Genesis 5:1-2. Keep it where you can review it often this week. Ask God to renew your mind with this truth.

Notes

- Jack Hayford, ed., The Spirit-Filled Life Bible (Nashville, TN: Thomas Nelson Publishers, 1991), p.
 1195. Verse 13 would also lend credence to this view. The king of Tyre could not have been in the
 Garden of Eden because in his time it no longer existed.
- 2. J. P. Green, ed., *The New Englishman's Hebrew Concordance* (Peabody, MA: Hendrickson Publishers, 1984), #398.
- 3. DeVern Fromke, The Ultimate Intention (Cloverdale, IN: Sure Foundation, 1963), pp. 60-61.
- Watchman Nee, The Messenger of the Cross (New York: Christian Fellowship Publishers, 1980), pp. 130-131.
- W. E. Vine, An Expository Dictionary of New Testament Words (Grand Rapids, MI: Fleming H. Revell Co., 1966), p. 319.
- R. Laird Harris, Gleason L. Archer Jr., and Bruce K. Waltke, Theological Wordbook of the Old Testament (Chicago: Moody Press, 1980), #1924a.
- 7. Marvin R. Vincent, Word Studies in the New Testament (Peabody, MA: Hendrickson Publishers, nd).
- 8. Francis Brown, S. R. Driver and Charles A. Briggs, *The Brown-Driver-Briggs Hebrew and English Lexicon* (Peabody, MA: Hendrickson Publishers, 1996), p. 179c.
- 9. Harris, et al., Theological Wordbook of the Old Testament, p. 740b.

THREE

THE STRIKE

Now the serpent was more cunning than any beast of the field which the LORD God had made.

GENESIS 3:1

God had a great plan for the man and woman that He had created and for their resulting progeny. It was a powerful plan, beautifully and precisely designed, and all of the universe looked on in wonder. God would rule the earth through His children, and as they received His life, they would represent Him in nature and in authority. Of course, the success of this plan depended on the man and woman's allegiance to God, their unity and the full expression of who they were—male and female.

PART ONE: SATAN'S TACTICS

Some of us may remember the explosion of the Challenger space shuttle right after liftoff at Cape Canaveral back in 1986. Others may remember the Columbia space shuttle disaster in 2003, when the craft broke apart over Texas as it reentered the earth's atmosphere. Each of these shuttles were carefully designed and powerfully crafted, yet they both blew apart, killing all of the beloved people aboard. Stunned, people all over the world were asking, "What happened? What went wrong?"

Our goal in this chapter is to answer a similar question that arises out of a far greater catastrophe: to discover the clear tactics of Satan as he overthrew (for a time) God's carefully designed plan for His creation. We will also look at the devastating results that occurred in the lives of not only Adam and Eve but also in every man and woman since that time.

A Closer Look at the Problem

God first created the man, observed a problem, and then brought forth the woman to help the man. Rather than being a help, however, the woman exacerbated the problem! The design exploded, and all that was left was a faint resemblance to what God had originally fashioned. So, what happened? How could something so carefully designed go so terribly awry? Genesis 3:1 gives us our first clue:

Now the serpent was more cunning [subtle and crafty] than any beast of the field which the LORD God had made. And he said to the woman, "Has God indeed said, 'You shall not eat of every tree of the garden'?"

Satan is a master tactician. He did not come to Eve with a haphazard plan to just mess things up for God for a while. He knew exactly what was needed in order for Adam and Eve to fulfill God's mandate for them, and he knew what he had to do to steer them away from God's provision for them (the tree of life) and toward the tree of the knowledge of good and evil.

them (the tree of mo) and to war a site of the site of
What have we learned the tree of the knowledge of good and evil represents?
Why was it so crucial to Satan that he snare Adam and Eve into eating of the tree of the knowledge of good and evil and not the tree of life?
Satan was successful in his temptation. Both Adam and Eve ate of the tree of the knowledge of good and evil (see Genesis 3:6). It was a coup, a masterstroke, a bull's-eye! Satan had successfully separated them from the one source of life that was stronger than him. What did this now mean for Adam and Eve?

"You Gotta Serve Somebody"

The title of Bob Dylan's song "You Gotta Serve Somebody" is absolutely true: we all make the choice by whom we will be influenced and ruled, even if we are not conscious that we are making that choice. As Paul states, "Do

you not know that to whom you present yourselves slaves to obey, you are that one's slaves whom you obey" (Romans 6:16). In Adam and Eve's case, Satan had turned them to self-rule. However, humanity was never designed to function independent of a higher power.

While Adam and Eve thought they were choosing independence, in actuality by whom would they now be ruled?

Because of Adam and Eve's choices, a new system in the world was estable.

Because of Adam and Eve's choices, a new system in the world was established. Read 2 Corinthians 4:4; 1 John 2:15-16 and 5:19. What changed after Adam and Eve sinned?

Now that Adam and Eve were living from their self-centers, they would judge everything in life by the immediate effect it had on them. If something felt good or comfortable, they would consider it good. If something felt painful or uncomfortable, they would consider it evil. What are some of the ways those who lean on their own understanding in this way pursue what they think is good as opposed to evil as they develop their lifestyles? (What would influence their choices as they design their lives?)

How might this understanding of good and evil as it relates to our own selfcenteredness affect the way we view and relate to those of the opposite sex?

THE DESIGN DISINTEGRATES

Adam and Eve's choice brought into being the world system over which Satan as the "god of this world" would preside. As such, it shouldn't surprise

us that life as it was supposed to be took a 180-degree turn. The result of Adam and Eve's action was instantaneous: a broken relationship with God.

When Satan moved to derail the man and woman, he struck directly at the center of their identities—their maleness and femaleness. It's noteworthy that before Adam and Eve hid themselves from God in the garden, they covered themselves from each other—they covered the parts of themselves that identified them as male and female. They became driven by their self-centers. Who they were and how they were designed to function would now be confused, twisted, deceptive, hidden and self-serving.

What are some of the ways that women, whom God created to be nour-ished and cherished by men, are today throughout the world being poorly treated, abused or neglected?
The highly regarded theologian Matthew Henry stated, "[The woman] was made subject to [the man] because she was made for him, for his use, help and comfort. And she who was intended to always be in subjection to the man should do nothing, in Christian assemblies, that looks like the affectation (pretense) of equality." In what ways are the seeds of this viewpoint still affecting the Church today?
We have seen that men, instead of serving their wives and receiving them into the intended place in their lives, have sought to use them, objectify them or patronize them. How would this attitude fit right into Satan's objective to destroy the effectiveness of women and thus the health and well-being of men?

The word "objectify" means "to present (something or someone) as an object; depersonalize them." What are some ways men objectify women?
THE DESIRE OF THE WOMAN The fruit of people's walking by their own knowledge of what is good and what is evil has been devastating. Not only have men's attitudes toward women been dramatically affected by the Fall, but also women's attitudes toward men have been affected. We hear God addressing this very thing as He speaks to Eve immediately after she and Adam partook of the forbidden tree.
Read Genesis 3:16. Note that the words "shall be" are not actually in the original text. The added words make it sound as though God is telling Eve, "You must desire your husband, and he must rule over you." The literal translation of this verse would actually be, "Your desire to your husband and he will rule over you." In essence, God was saying to Eve, "The desire of your heart is turning away from Me to your husband, and he will rule over you." How will this shift change her relationship with God?
Note that this attitude in the woman's heart extends to the male race in general, but it becomes specifically focused on the husband at marriage. Review the definition of the word "objectify" above. What are some ways that women objectify men?
OUR "GOD" REIGNS How do the things we set our desires on rule us and become our gods?

Do these gods reign as an overt action on their part, or is it attitude of our
own heart?
Who, then, holds the key to dethroning these gods and replacing them with the true God?
Jane notes, "You only have to look around you to see how women, even Christian women, set their desire on men." What evidence of this desire do you see being played throughout the world today?
The Beginning of the End
What unspoken expectations do many women have about their husband when they enter into marriage? What do they think he will provide for them?
What are some of the results when these expectations are not met?
Our focus in this section has been on the problem. Only God can fix this problem, for the tear has been too deep and too wide, and the devastation

has been too catastrophic.

A Closer Look at My Own Heart

The following questions are not intended to condemn or pass judgment on you in any way. The goal is for you to simply attempt to take an honest (though perhaps difficult) look at your own heart.

Consider your attitudes toward the opposite sex in general and, if mar-
ried, your spouse in particular. Has the way you relate to them been shaped
by your own knowledge of good and evil? Is their worth and acceptance to
you based mainly on your self-centered perception of how they fit into
your life and agenda?
This question is directed specifically to women. Think about the "desire of
the woman." Are you looking to your husband to fill what only God can fill?

One of the ways you can tell if this is an issue is if you struggle with disillusionment, anger and bitterness because of disappointed expectations. Remember that a person does not have to be married to be struggling with the aforementioned desire. A person can be single and still be looking for that "one" who will make everything okay, meaningful and worthwhile—the one whose approval and affection will deem you a worthy and acceptable person.

Action Steps I Can Take Today

Sometimes, the only way you can know how you are relating to others is by asking them. If you are married, set up a time to talk with your spouse. Ask if he or she perceives you are relating to him or her out of your own expectation and personal agenda. Determine not to be offended by the response but to talk it through and attempt to grow through understanding each other.

If you are unmarried, ask one or two close friends to talk through with you the truths in this chapter. Use the time to gain greater perspective of your own expectations and desires toward the opposite gender.

Take the whole matter to God in prayer. He will hear you. He has a vested interest in restoring your relationships!

PART TWO: RIGHT EXPECTATIONS, WRONG SOURCE

Like the tragic demise of the Challenger and Columbia space shuttles we mentioned in the previous section, God's beautifully designed plan for His people quickly disintegrated. God's image was corrupted as His design became engulfed in the flames of self-centeredness. We see the fallout from that explosion all around us to this day. In *Fashioned for Intimacy*, Jane stated the following:

We are fashioned for intimacy, we long for love and a sense of true caring. Yet, because of the Fall, we live in a world of broken people driven by our own needs and self-centers. We move toward others, based not so much on what they need, but rather on what we need, endeavoring somehow to slacken the hidden thirst deep within our souls. What is the answer to our dilemma then? Are our longings and expectations so unrealistic that they can never be met in this lifetime? Dr. Reed Davis addresses our question when, in essence, he says, "It is a question of 'source or resource.' God is our source, others in our lives are resources."

Read Jeremiah 2:13. How does the prophet describe anything we u	ıse	as a
source other than God?		

Our goal in this section is to sort out what God, our Source, intends to be to us, and then, as resources, what He intended husbands and wives (and others) to be to each other. We want to uncover the "broken cisterns" that we have fashioned in our lives.

A Closer Look at the Problem

Because of the Fall, we grow up in this world with a skewed perspective. We continually interpret life through the eyes of our own self-centeredness. Before God is able to renew our minds, we have built our lives on a false foundation. It would be wonderful if, once we realized our error, God

would simply come in and magically give us a right foundation on which we could build a satisfying, God-glorifying life. However, as DeVern Fromke states in *The Ultimate Intention*, "Before positive restoration can proceed, false foundations must be exposed and destroyed." 5

EXPOSED FOUNDATIONS
One of the foundations being exposed today is the "desire of the woman
Since the time of the Fall, this desire has caused women to find their b
ing in men. Why is it so important that this foundation be exposed?
and the state of t
"Being needs" are those needs that relate to one's identity, worth, purpos
security and desire to be loved. In what ways have you seen people attempt
to meet these needs?
to meet these needs:
Are "being needs" legitimate needs? Why or why not?
Both men and women have being needs, but they tend to look to diffe
ent places to fill them. Where do women tend to look to have their bein
needs filled?
vv1
What are some places men tend to look to have these needs met?
William Company to the Company of th

Note that the word "toil" in verse 17 means "worrisome, i.e. labor or pain, sorrow, toil." It refers to "physical pain as well as emotional sorrow." The word "sweat" in verse 19 means "as caused by agitation and fear." What do the words "labor," "pain," "sorrow," "toil," "agitation" and "fear" tell us about how a man who does not depend on God as his source would relate to his work? Why do you think this is so? How might this anxiety and turmoil concerning his work affect his relationships? UNCOVERING THE SNARE What was Satan's ultimate goal in his temptation of Adam and Eve (see Romans 8:20-21)? In his book <i>The Marriage Builder</i> , Larry Crabb states, "Everything we do represents an effort to reach a goal that somehow, perhaps at an unconscious level, makes good sense to us. Imbedded in our make-up are certain beliefs about how to be become worthwhile or how to avoid injury to our self-esteem, how to be happy or how to avoid pain." According to this quote, what determines our goals and expectations?	Read Genesis 3:17-19. What was the primary result of Adam's choice to depend on himself instead of God?
Uncovering the Snare What was Satan's ultimate goal in his temptation of Adam and Eve (see Romans 8:20-21)? In his book <i>The Marriage Builder</i> , Larry Crabb states, "Everything we do represents an effort to reach a goal that somehow, perhaps at an unconscious level, makes good sense to us. Imbedded in our make-up are certain beliefs about how to become worthwhile or how to avoid injury to our self-esteem, how to be happy or how to avoid pain." According to this quote,	sorrow, toil." It refers to "physical pain as well as emotional sorrow." The word "sweat" in verse 19 means "as caused by agitation and fear." What do the words "labor," "pain," "sorrow," "toil," "agitation" and "fear" tell u about how a man who does not depend on God as his source would relate
What was Satan's ultimate goal in his temptation of Adam and Eve (see Romans 8:20-21)? In his book <i>The Marriage Builder</i> , Larry Crabb states, "Everything we do represents an effort to reach a goal that somehow, perhaps at an unconscious level, makes good sense to us. Imbedded in our make-up are certain beliefs about how to become worthwhile or how to avoid injury to our self-esteem, how to be happy or how to avoid pain." According to this quote,	· ·
resents an effort to reach a goal that somehow, perhaps at an unconscious level, makes good sense to us. Imbedded in our make-up are certain beliefs about how to become worthwhile or how to avoid injury to our self-esteem, how to be happy or how to avoid pain." According to this quote,	What was Satan's ultimate goal in his temptation of Adam and Eve (se
	resents an effort to reach a goal that somehow, perhaps at an unconscioud level, makes good sense to us. Imbedded in our make-up are certain be liefs about how to become worthwhile or how to avoid injury to our self esteem, how to be happy or how to avoid pain." According to this quote

The desire (teshuqah) of the woman was a deep inner longing that was "turning away" and "stretching out after" the man. This was not part of the curse; God was just uncovering a snare to Eve. Because she was turning away from the living God—the one true source of life—she would now be ruled by the false source of life to which she was turning. What was this false source of life that would now rule her?
Why is satisfaction found in a wrong source or false god always temporary?
How can these false gods ("broken cisterns") affect your choices?
EVIDENCE OF EXPECTATIONS Jane notes, "The desire of the woman is a heart-held belief. It is the belief that her husband can be her source of life, that he can meet her need for unfailing love, worth, security and purpose." Our heart-held beliefs will be evidenced by our behavior. What behavior do you see in women that is evidence of this heart-held belief?
The desire of the woman causes her to look to her husband for her life (her being needs). Because she is looking to her husband for her life, he will "rule" her emotionally. What effect will this have on her when he says something that she doesn't like or with which she doesn't agree?

A Closer Look at God's Truth

In <i>The Ultimate Intention</i> , DeVern Fromke states, "Until we have truly been cut loose from the old tree, which is wild by nature, and grafted into the good tree, we have not learned to live from our new source." In other words, unless we become aware of how much we are still living life from the old tree, we will not truly be cut loose from it. We will not sense our need for this divine surgery. What happens to our relationships when we find our life—our "being" needs—in God?
Why are we able to move in true intimacy with others once we have found our life in God?
A DIVINE TURNING Of course, there are many legitimate needs that must be met in the marriage relationship for it to function properly. However, what so often trips up women is that they fail to separate their being needs from their relational needs. What do you see as the difference between the two?
What often makes women vulnerable to the deception that her husband should meet all of her needs is that what she wants is "good" and even necessary. Read Genesis 3:6. How do we see Eve's vulnerability to being deceived by good demonstrated in her life?

The Strike 55

Were all of the things the tree of the knowledge of good and evil offered things that God did not want Eve to have? What was the real issue here (see Jeremiah 2:13)?
Right things from the wrong source constitute lust. Why was the desire of the woman a form of lust? In what way was it a form of spiritual adultery against God?
What happens to a woman when she sets her desire back on God? In what ways is she set free?
Jane states, "When the woman stops looking to her husband for the needs he cannot meet, she frees him to meet the ones he can." This dynamic also applies to a husband in relationship with his wife. What do you think are some of the needs God intends husbands and wives to meet in each other?

A Door Unlocks

In Fashioned for Intimacy, Jane relates how she and her husband, Howard, experienced incredible freedom when they gave up their heart-held beliefs that had caused each of them to look to the other as their source of life. However, even though Jane had extended much forgiveness for past hurts, she found that she was still not free in her relationship with Howard. It was through a fresh understanding of the parable of the unmerciful servant that she saw it was not only the past debt she must forgive but also the daily debt of their relationship—the new expectations that surfaced every day.

Read this parable in Matthew 18:22-35. What was the ultimate state of both servants?
Even though the first servant knew that he had been completely forgiven of his debt, he didn't fully understand how entirely impossible it was for him to pay it and how utterly dependent he was on the grace and mercy of the king. How does the way we view ourselves before God affect the way we relate to others?
A Closer Look at My Own Heart
In 1 Timothy 6:17, Paul says, "[Do not] trust in uncertain riches but in the living God who gives us richly all things to enjoy." To this, a wise teacher once responded, "You can tell when you have put your hope in things—riches, people, home, cars, etc.—you stop enjoying them. When we put our hope in God, we enjoy Him and other things as well." To this list we could also add "work." Is there anything or anyone you have stopped enjoying that you know God intends for you to enjoy?
There may be other things in which you are still attempting to find enjoyment, but you know that ultimately they will never bring the satisfaction to your soul you are looking for. What are some of these things in your life?
The things on your list are good clues that will lead you to the discovery of some of your "broken cisterns"—containers that cannot hold water.

Action Steps I Can Take Today

God never shows us a truth to condemn us, but only to bring us to the place where, through repentance and prayer, we will ask Him to do what only He can: perform open-heart surgery.

Today, come before the Lord with an open heart. Tell Him that you have made for yourself broken cisterns and the water you were seeking to satisfy your soul has long since leaked out. Tell the Lord what your broken cisterns are. Ask Him to forgive you for making these persons or things "gods" to whom you have looked to give you life, meaning and security.

Write John 4:14 on a card: "But whoever drinks of the water that I [Jesus] shall give him will never thirst. But the water that I shall give him will become in him a fountain of water springing up into everlasting life." Put this in a place where you will see it this week. As you meditate on this verse, ask the Lord to give you a fresh revelation of Himself as the "water of life" and His intention to abundantly satisfy you now, in this life, and in the one to come.

Notes

- Matthew Henry, Commentary on the Whole Bible, vol. 6 (Grand Rapids, MI: Fleming H. Revell Co., nd), p. 562.
- The American Heritage Dictionary of the English Language, third edition (Boston, MA: Houghton Mifflin Co., 1992).
- 3. Jane Hansen Hoyt with Marie Powers, Fashioned for Intimacy (Ventura, CA: Regal, 1997), p. 69.
- 4. Ibid., pp. 73-74.
- 5. DeVern Fromke, The Ultimate Intention (Cloverdale, IN: Sure Foundation, 1963), p. 69.
- James Strong, Strong's Exhaustive Concordance of the Bible (Grand Rapids, MI: Baker Book House, 1984), Hebrew #6093.
- R. Laird Harris, Gleason L. Archer Jr. and Bruce K. Waltke, eds., Theological Wordbook of the Old Testament (Chicago: Moody Press, 1980), #1666, p. 687.
- 8. Strong, Strong's Exhaustive Concordance of the Bible, Hebrew #2188 and root #2111.
- 9. Larry Crabb, The Marriage Builder (Grand Rapids, MI: Zondervan, 1982), p. 48.
- 10. Hansen Hoyt with Powers, Fashioned for Intimacy, p. 75.
- 11. Ibid., p. 76.
- 12. Fromke, The Ultimate Intention, p. 69.
- 13. Hansen Hoyt with Powers, Fashioned for Intimacy, p. 80.
- 14. Ibid., p. 78.

HIDDEN MAN OF THE HEART

As in water face answereth to face, so the heart of man to man.

PROVERBS 27:19, KJV

In the last chapter, we uncovered one of the greatest barriers to intimacy: viewing our relationships with others as "sources" of life rather than the "resources" that God has given us for our growth and good. Only God can be our Source of life. It is when we find our identity, worth, purpose, security and unfailing love in Him that we will gain the courage to risk reaching out beyond ourselves to connect more deeply with others on a consistent basis.

Having established that God intended people to be merely resources in our lives, and being free now from grasping after them for what they cannot give us, we are ready to look more closely at what intimacy is and how we can begin to move toward this deeper level of relationship.

A Closer Look at the Problem

One of the most common complaints among women worldwide (and the source of much disappointment, grief and pain) is the emotional absence of their husbands—to them and their families. No amount of busyness or determination to find satisfaction in other things will quench this deep longing in women.

The fact of the matter is that God didn't intend for anything else to quench this longing. God designed women with an inner need to have an intimate relationship with their husbands—one that goes deeper than just the sexual relationship, which at first might have seemed enough by itself. It is precisely this point that many, if not most, marriages break down. Other couples—many of them Christians who do not believe in divorce—get stuck at this point. Unless they discover God's plan and purpose for them, they will live for years in quiet desperation and pain.

THE HONEYMOON IS OVER We often hear people say "the honeymoon is over" when speaking of newly married couples. What is meant by this?
What often begins to happen within a woman after the early stages of marriage are over as it relates to her physical or sexual desire for her husband?
What do you think is typically the husband's response to this turn of events?
Many task-oriented husbands consider themselves "responsible" because they come home every night and bring home their paycheck. They feel that this makes them committed to the marriage. What is wrong with this line of thinking as it relates to a woman's need to connect emotionally and relationally to her husband?
What is the difference between being committed to a principle and being committed to a person? How would this affect the relationship?
What is a woman really saying to her husband when she says things like, "You don't really care about me" or "I want a relationship with you"?

Gary Smalley says, "Women have a marriage manual in their hearts." What
does this statement mean in terms of how women seem to instinctively
know that a relationship needs to go beyond the surface level to thrive?
God often uses the unrest and dissatisfaction with the status quo in the woman's heart to move the couple to their next level of growth. However, what does the husband and wife in the marriage have to do in order for this growth to occur?
A Closer Look at God's Truth
God has specifically designed women with an inner need to move past the
surface in a relationship and get to the heart of things. Why do you think
women find it easier to move into the realm of feelings than men?
4
Although we should not be controlled by our feelings or depend on them as an infallible source of truth, what can those feelings and emotions tell us about ourselves as we begin to process them?
Proverbs 27:19 states, "As in water face answereth to face, so the heart of
man to man [one human being to another]." It is in the mirrored effect of relationships that we are confronted with what is in our hearts. How can relationships help us to see the "blind spots" that exist in our lives?

How would a woman's ability to more readily identify and process emotions affect her husband if he received her on this open and transparent level?
*
Fashioned for Intimacy
Jack Hayford states that the book of 1 Peter is written to "Christians living in various parts of Asia Minor who are suffering rejection in the world because of their obedience to Christ" (see 1 Peter 4:1-4,12-16). Read 1 Pe-
ter 3:1-6, and then read 1 Peter 2:21-23 and 3:8-10, which bracket this passage and provide its context. Note that these latter two passages refer to
Jesus' behavior as our example to follow. What do these passages say about Jesus' interaction with His detractors?
Is 1 Peter 3:1 telling us that a woman is not to use any words at all in her relationship with her husband? Given the context, what is this passage telling us?
We are told that the woman's submission is to be as one who is adorned with "the hidden person of the heart" (1 Peter 3:4). The heart denotes "thoughts, feelings, mind, middle." It is the deepest and most inner recess of our being—the place where the real us dwells. How would a woman who is so adorned with "the hidden person of the heart" relate to her husband?

BE PREPARED FOR REACTIONS

Living in true relationship takes wisdom and courage. First Peter 3:6 admonishes women not to be "afraid with any terror." The word "terror" in the original Greek means "to scare or frighten" and is perhaps akin to a

word that means "to fly away." What could cause a woman to feel terror as she begins to share her heart with her husband?
In their book <i>The Transformation of the Inner Man</i> , John and Paula Sandford state, "Companions and counselors must search patiently to find the frozen hearts of their friends. But the most common sign of returning to life is that the warmer the love given, the meaner the response. Fear of vulnerability creates that. Each stony heart has a life of its own." According to the Sandfords, what would be one cause for a husband's withdrawal from overtures of intimacy from his wife?
What do you think of the Sandfords' explanation? Have you seen this in your own relationships?
First Peter 3:14 states, "But even if you should suffer for the sake of right-eousness, you are blessed. And do not fear their intimidation, and do not be troubled" (<i>NASB</i>). According to this verse and the passage you read in 1 Peter 3:6, what should be the attitude of anyone—man or woman—who trusts in God in the face of rebuffs, angry responses or suffering?
How will a woman who has learned to trust in God respond to her husband (see Proverbs 3:3-4; 18:21-22; 31:26; Ephesians 4:15,26)? How could her example help her husband?

RULES OR RELATIONSHIP?

God's goal is always relationship, but not relationship at any cost. It must be relationship without guile or deceit (see 1 Peter 3:10), founded on mercy—which springs from love—and truth. Love is critical, but love without truth is not genuine love; it is just manipulative and self-serving. On the other hand, truth without love will destroy rather than heal and bring life (see 2 Corinthians 3:1-6).

This is true submission "as unto the Lord." It is more about *relationship* than *authority*. Submission is a woman knowing her purpose from God's viewpoint and then bringing her whole self to the man for his good, knowing that their destiny is together.

what is the difference between rule-oriented submission and relationship oriented submission?
According to Understanding
According to 1 Peter 3:7, a man is to understand his wife—understand the
nature and design that God has given to her for his help. How is the mar to treat his wife? Why?
While it is true that only God can give the husband "life" in the eternal sense, the wife can lead him into life so that even eternal things take on a greater significance for him. How can a woman enrich her husband's life and promote growth in his relationship with God?
Paul Tournier states, "For a person to achieve his or her potential, there must be at least one other person with whom he or she is totally open and

feels totally safe at the same time." What will happen if we remain hidden and self-protective?
Dr. v. Mrsv. Do
REAL MEN DO
In her book <i>The Men We Never Knew</i> , Daphne Rose Kingma states, "Men have been taught that in order to hold the world together, to make political, economic or social decisions, they have to ignore their emotions because the intervention of 'feelings' could make mincemeat of their choices." How
does life and society conspire to keep men emotionally closed?
What are some strategies that men have learned to protect themselves from emotions that would label them "unmanly" or "unmasculine". What is the danger, the cost, to men for their self-protectiveness?
What is the effect of men's tendency to isolate themselves on the home family, church and nation?
A man whose heart has begun to trust his wife will gain courage to shar with her the wounds and failures of the past (see Proverbs 31:11). Wha does God intend to happen within the emotional intimacy of relation ships (particularly in marriage)?
9-1 * C
<u> </u>

A Closer Look at My Own Heart

One man, struggling to take his God-ordained role as a full participator in his family, said, "How could I know that my family had emotional needs when I didn't know I had them myself?" This may be the case in your life. You can't begin to meet the emotional needs of others until you identify your own needs and begin to process them.

Men (and some women), in light of the cost of emotional abandonment to your family, have you fully entered into this dimension in your life and the lives of others to whom you have a relational responsibility? Women, have you fully understood your role as a help in your husband's life, or have you succumbed to discouragement and perhaps the fear that comes with his rebuffs?

Action Steps I Can Take Today

Pray for greater sensitivity to your own feelings and those around you. Ask for wisdom to communicate in non-threatening ways and courage to break through any self-protective ways that you might have in your life.

Knowing that you are secure in God, that He is your Source and that you no longer need to fear what people can do to you, make a verbal commitment to someone—to your spouse if you are married—to begin being more honest and open with him or her.

This will be an ongoing process, so commit to a specific time to be with this person on a consistent and frequent basis. Schedule activities that will be conducive to meaningful conversation.

Notes

- 1. George Guilder, Men and Marriage (Gretna, LA: Pelican Publishing Co., Inc., 1986).
- 2. Jack Hayford, ed., The Spirit-Filled Life Bible (Nashville, TN: Thomas Nelson Publishers, 1991), p. 1905.
- Walter Bauer, William F. Arndt, Wilber Gingrich and Frederick Danker, eds., A Greek-English Lexicon of the New Testament and Other Early Christian Literature (Chicago: The University of Chicago Press, 1957), pp. 403-404; Gerhard Kittel, ed., Theological Dictionary of the New Testament (Grand Rapids, MI: Wm. B. Eerdmans Publishing Company, 1967), vol. 3, p. 415.
- Bauer, Arndt, Gingrich and Danker, A Greek-English Lexicon of the New Testament and Other Early Christian Literature, p. 727c.
- John and Paula Sandford, The Transformation of the Inner Man (South Plainfield, NJ: Bridge Publishing, Inc., nd), pp. 217-218.
- Paul Tournier, quoted in John Powell, Will the Real Me Please Stand Up (Allen, TX: Tabor Publishing, 1985), p. 12.

MNMASKING THE ACCUSER

The accuser of our brethren . . . has been cast down.

REVELATION 12:10

In this chapter, we will examine another barrier to intimacy that is closely related to the first barrier we discussed—seeing others as our source of life—that warrants special attention. As we begin to share ourselves with others, we will find ourselves wanting to flee back into our hiding places deep within us. This is a favorite tactic of the enemy called "false shame," and it showed its deceptive face in the very first temptation in the garden. For this reason, it is essential that we understand this favorite weapon of Satan so that we may remove his power in our lives.

PART ONE: FALSE SHAME AND TRUE SHAME

The goal in this first section is for you to gain discernment between false shame and true shame so that you may walk away free from both.

A Closer Look at the Problem

Someone has said, "Children are terrific observers but terrible interpreters." Children are quick to notice everything going on around them, but their interpretation of those events, if left to themselves, will be woefully lacking.

Because children are extremely egocentric, they tend to interpret life as being all about them. They are not capable of accurately evaluating the validity of the words and actions of others, no matter how inappropriate. Like sponges, they soak in judgments about their identity and value and view it as gospel truth. When people say or do bad things to them, they are likely to believe these things happened to them because they are bad people.

All of us were children, and all of us, for the most part, are still dealing with the negative messages we received when we were young. Psychologists say that by the time we reach our teenage years, each of us has, for the most part, formed our core beliefs about ourselves. By then, based on our interpretation of the messages around us, we have decided whether we "measure up," and our identities as people are generally firmly in place. This now becomes who we are, and many of us never again question that evaluation. We filter any new information we receive through that belief system, and we use it to cement what we already "know" about ourselves.

Messages come to us in many ways and from many fronts. What are some

of the different ways we receive messages about ourselves?
What are some of the messages that we receive?
In Fashioned for Intimacy, Jane states, "It is normal to form our pictures of ourselves from the messages we receive around us. God intended it to be that way—that who we are would be mirrored by others in our lives, affirmed and confirmed by them." In the perfect world that God had planned, all the voices in our lives would have been positive. What happened to disrupt that perfect plan?
As a result, what kind of inner picture do most of us have of ourselves? Why is it so essential that we be healed?

THE THIEF OF INTIMACY Proverbs 22:15 states, "Folly is bound up in the heart of a child, but the roof of discipline drives it far from him" (ESV). Satan comes to us early in our lives, and he comes with a purpose. Why do you think Satan chooses this time in our lives to cripple us?
In <i>The Spirit-Filled Life Bible</i> , Jack Hayford defines Satan as "an opponent, or the Opponent; the hater; the accuser; adversary; enemy; one who resists obstructs and hinders whatever is good." Because this is Satan's nature how can we identify his voice in our lives?
Remember that Satan's goal for Adam and Eve's lives was to turn them from being God-focused to being self-focused. He knew that if he could turn them to themselves, they would have no power against him, and he would be safe from them. Satan uses the same tactic today. Although he can't steal our salvation, he knows that he can cripple God's purposes in our lives if he can cause us to become self-focused. Read Genesis 3:1. When the serpent came to Eve and told her that the fruit from the forbidden tree would make her be "like God," what was he implying? What was he saying about how God had provided for her every need?
Satan's message to Eve was that she was not enough, that God was not enough to make her enough, and that she needed something else from the world to make her enough. ³ This is the "shame message" we hear when we are feeling inadequate, though we are not always able to articulate the words Part of this message was true, and part of it was a lie. Which was which?

Eve believed the lies and the implication that there was something wrong with "not being enough." So she reached out with her own hands to make up the deficit that she perceived to be within her. Adam followed her example. By focusing on themselves in this manner, they broke the bridge between them and their true Source of Life. Now, wholly dependent on themselves, what had initially only been a perceived deficiency became a true one. They were naked, exposed and in danger of being rejected and abandoned forever.

Two Kinds of Shame
Read Revelation 3:17-18. What do we feel if we are found naked and exposed?
*
Why does God allow us to feel this sense of legitimate shame, which is the result of us going our own way? What is He trying to get us to do?
What is God's remedy for our condition?
There is another kind of shame called "false shame," and it is generally the precursor of sin. False shame is Satan's attempt to convince us there is something wrong with us when there is not. He does this to cause us, like Adam and Eve, to take things into our own hands and seek out whatever we think is lacking. Satan came to Eve before the Fall with this lie that it was unacceptable for her to be insufficient, and he comes to us with the same lie today.
Satan will often come to us after we receive salvation. What does he whisper into our minds about how we "measure up" with other Christians, and what is often the result?

False shame is an accusation about who we are that strikes at the core of our being. It tells us that we are flawed, defective, unacceptable or lacking in whatever it takes to make life work. As one man stated, "it is as if everyone else had received a manual about how to get along and be loved and at home in life, and we hadn't got one." Have you ever felt this way? If so, what did you do about it?
Hide and Seek
Once we decide that we are flawed, unacceptable and irreparably defective, what do we do to make up the perceived deficit in our lives?
What is your hiding place—the behavior you find yourself reverting to when you become fearful that someone may find the real you?
Isaiah 28:20 states, "For [they will find that] the bed is too short for a man to stretch himself on and the covering too narrow for him to wrap himself in. [All their sources of confidence will fail them.]" How does this verse relate to our dilemma?
THE BAGGAGE WE BRING Many of us bring this distorted, self-focused and defective view of ourselves into our relationships. How would this affect our marriages?

In <i>The Silence of Adam</i> , Don Hudson states, "For years, I pretended I was adequate. But I was playing a game. There were, in my past, devastating circumstances that told me I was deficient. To admit such a deficiency, however, meant death for me. Even though I felt inadequate in everything, I put up a competent front." How do you relate to these words?
How have you personally responded to your sense of deficiency as you have related to the world around you?
Read Proverbs 18:19. One who has been offended has built a strong, fortified hiding place around himself or herself. What happens to a person who builds these impenetrable defenses to keep others out?
In <i>Fashioned for Intimacy</i> , Jane tells how both she and Howard attempted to make up their sense of inadequacy in different ways. Howard appeared confident, friendly and happy, but he was so insecure that he treated any overtures for intimacy or requests for a change in the status quo with anger and intimidation. Jane, on the other hand, majored in perfection. She tried to be the best at everything. Yet she could do nothing to make her marriage measure up to her perfect standard. She saw this as a personal failure, and this caused her to focus even more on Howard's behavior.
Read Matthew 18:21-35. This parable of the unforgiving servant reveals a profound dynamic: neither servant asked for forgiveness. What did they ask for instead? Why?

What does this reveal about them? What were they not grasping about their actual state?
their decidal state.
the state of the s
What was the end result?
A Closer Look at God's Truth
Nancy Groom, in her book <i>Marriage Without Masks</i> , states, "[We must] repen of our sinful strategies of self-protective unlove toward our spouses, [but first we must acknowledge that our self-sufficiency is the root sin demanding our repentance." Why is self-sufficiency a root sin? Why must we repent of this sin before we can repent of other sins such as our failure to love others?
Nancy states, "Repentance involves two things: recognizing the sinful purpose of our lives (to stay out of pain by protecting ourselves in any way we can) and embracing a new purpose (to utterly trust God for our inner lives by dropping our self-protection and moving with openness toward our mater according to their legitimate needs)." Why is it important to seek these things in our lives? What is the result if we do not take both of these steps:
In what ways will our commitment to "staying safe" (protecting ourselves) in our marriages and other relationships hinder what God wants to accomplish in our lives?

In Dying, We Live
What is the answer to the terrifying sense of insufficiency from which all
of us suffer? Is it the self-affirmation we so often hear about—pasting pos-
itive statements about ourselves on the bathroom mirror, hoping that if we
say them often enough we will finally believe them? How do we obtain
true freedom from our sense of insufficiency?
* 1 -
The very thing of which Don Hudson was terrified-admitting his defi-
ciency-is the thing that God is after in all of us. It will mean "death" to us,
just as Don feared, but it is the right kind of death: death to looking to our-
selves and others as our source of life and acceptance and death to our self-
dependence. Read Luke 9:23-24. How do these verses relate to this truth?
dependence return and a second
As previously stated, the message that tripped up Eve was not merely that she was insufficient but also her interpretation that, as such, her condition was flawed and unacceptable. What is the difference between being insufficient and being defeating.
ficient and being defective?
What are some ways in which you feel you are "insufficient"?
As fallen creatures, we are defective. Only God's life in us has ever allowed us
to be acceptable to Him (see 2 Corinthians 3:4-5). What happens when we
free ourselves of the "masks" we wear to cover our perceived inadequacies?

What happens when our God-centered selves begin to emerge? What might
be the effect on those around us?
<u> </u>
<u>er ligerten de Symphet et et de erziet de de doministration de la ligerte de la ligerte de la ligerte de la de</u>
garanta de santegra de la filo de la filo de la composición de la filo de la composición de la filo de la filo
A Closer Look at My Own Heart
What are some of the ways you have "played the game" of staying safe in life and staying out of pain by protecting yourself in any way you can?
in the state of th
To whom are you devoted when you play such games? On whom are you depending?
the figure will be a section of the
The purpose of "masks" is to make ourselves look acceptable to others, which means that we are still looking to people as our source of life. Are you at the place in your journey of trusting God that you can start removing some of the masks that separate you from others? If not, why not?

Action Steps I Can Take Today

Ask the Lord to reveal your masks to you and how they originated. Spend some time writing down some of the messages you received about yourself as a child and the masks you consequently constructed to make yourself acceptable. Prayerfully make a list as the Holy Spirit brings them to mind.

Go to the person with whom you have committed to become more open and honest. Ask him or her to make this list the subject of your next meeting together. Bring your list, share your reasons for your particular masks, and pray together for healing and freedom.

PART TWO: A SNARE, A FETTER OR A CROWN?

King Solomon, who had at least 1,000 wives and concubines, wrote, "I applied my heart to know, to search and seek out wisdom and the reason of things, to know the wickedness of folly, even of foolishness and madness. And I find more bitter than death the woman whose heart is snares and nets, whose hands are fetters" (Ecclesiastes 7:25-26). Herbert Lockyer, in his book *All the Women of the Bible*, observes, "No man has ever lived who has had as much experience with women as King Solomon, who 'loved many [idolatrous] women.' "8 King Solomon knew firsthand the influence of women. Sadly, though, through his own choices, he knew more about their influence for evil than for good.

We have studied in previous chapters about the powerful influence God designed women to have in the lives of their husbands. In this section, our goal is to more clearly define what kind of influence women are to be.

A Closer Look at the Problem

First Kings 10:23 declares that "King Solomon surpassed all the kings of the earth in riches and wisdom." He was the wisest man in all the earth, anointed so by God. There had not been anyone like him before his time, nor did anyone like him arise after him. He began his reign with a "wise and understanding heart" (1 Kings 3:12), a deep love and dependence on the Lord. Yet there came a day when "the LORD became angry with Solomon, because his heart had turned from the LORD God of Israel," so that God announced, "I will surely tear the kingdom away from you" (1 Kings 11:9,11).

Read 1 Kings 11:1-4. What is it that turned the heart of King Solomon, the wisest man in the history of the earth, from God and thus brought him to spiritual ruin?

God intended women's influence to be felt, but He was after influence for "good and not evil" (Proverbs 31:12). She was to be a help "as to the Lord" (Ephesians 5:22). Let's look more closely at what is meant by this.

0		***	4
GOOD	OR	HV	(T)

GOOD OR EVIL!
In Fashioned for Intimacy, Jane writes about how self-center is the source of sin, though the actions of such a person do not always fit what we would define as evil. His or her actions may even appear "right" and "good" and have "good reason" behind them. Remember that the tree of the knowledge of good and evil looked "good" to Adam and Eve. As we are told in Proverbs 14:12, "There is a way that seems right to a man, but its end is the way of death." What is the source of behavior that seems right but has as its end the way of death?
Self-centeredness is idolatry. What is idolatry? Who are we worshiping?
The worship of other gods (people, money, power) is merely an effort to manipulate life so that it serves ourselves. As we saw in Ecclesiastes 7:25-26, Solomon describes a woman who is devoted to her own agenda in this way—who is attempting to manipulate life so that it serves her—as "more bitter than death" and one "whose heart is snares and nets, whose hands are fetters." The effectiveness of Solomon's life, especially as it related to God's kingdom, was greatly diminished by his love for such self-devoted women.
THE EVIL WOMAN In Scripture, an evil, idolatrous woman is often symbolized by the term "harlot" (see Proverbs 6:6-27). In God's eyes, harlotry is not limited to sexual promiscuity. What else is harlotry symbolic of in Scripture?
Is it possible to be a Christian woman and yet be seeking satisfaction apart from God's life and ways? Why or why not?

What are some way symbolized as hard	s that even Christiar otry?	n women may in	dulge in behaviors
			9 2
What is the purpo	se of this behavior?		
	1 1 2 1 1 1 1 1 1 1 1 1 1 1 1 1 1 1 1 1		28 y 2 y 2 y 2 y 2 y 2 y 2

A Closer Look at God's Truth

The characteristics of the godly woman, found in 1 Peter 3, are in direct opposition to those of the evil woman found in Proverbs 7. In the following chart, look up the Scripture reference for each characteristic and then write how the evil woman and the godly woman portray that characteristic. The first row is completed as an example.

Characteristic	The Evil Woman	The Godly Woman
Her words	Proverbs 7:21: She flatters with her words to ensure her own agenda is met	1 Peter 3:1: She is responsi- ble with her words—neither flatters nor severely criticizes
Her sexuality	Proverbs 7:16-19:	1 Peter 3:3
Her motives/ methods	Proverbs 7:10:	1 Peter 3:4-6
Her expression of satisfaction with life	Proverbs 7:11:	1 Peter 3:4-5
Her source of satisfaction	Proverbs 7:18-19:	1 Peter 3:1-6
Her stability	Proverbs 5:6:	1 Peter 3:4-5

The godly woman influences her husband for good. What is the purpose of this kind of influence? How does God view it?
Too Soon Old, Too Late Smart No doubt King Solomon eventually understood the folly of his choices in women, but such knowledge came too late in his life to do him any good. This doesn't have to happen to us. Whether we are male or female, it will be of great benefit for us to truly understand what is a virtuous (godly) woman. Proverbs 31 is a good place to start: "Who can find a virtuous wife? For her worth is far above rubies" (v. 10).
Look up Proverbs 3:13-15 and 8:11. Notice the similarity of these verses with Proverbs 31:10. Putting these verses together, what can we conclude about the value that God places on the godly woman?
Proverbs 31:11 states, "The heart of her (the godly woman's) husband safely trusts her; so he will have no lack of gain." "Safely trust" means "to run to for refuge, to be confident and sure or secure, a place of safety." Scripture frequently speaks of us putting our trust solely in God: "Trust in [the Lord] at all times, you people; pour out your heart before Him; God is a refuge for us" (Psalm 62:8). However, here in Proverbs we are told that a man who has found a godly wife can also safely trust his heart to her. What is the meaning of "safely trust" as relates to marriage?
Notice how Psalm 62:8 and the full meaning of Proverbs 31:11 resemble each other. What is God saying here about the virtuous, or godly, woman?

Remember that the word "heart" means "thoughts, feelings, mind, middle." How is the godly woman a safe haven for her husband's heart? How is this lived out in their lives?
is this fived out in their fives:
Read Genesis 2:25. How is this symbolic of the openness that God intended for men and women to have in marriage?
A man who has found a godly wife will "lack no gain," or, as the <i>New International Version</i> says it, "He will lack nothing of value" (Proverbs 31:11). In your estimation, what do you think is really valuable or gain in this life?
Proverbs 31:12 states that a godly woman "does him [her husband] good and not evil all the days of her life." Good is what proceeds from God; that which draws us toward God. According to Proverbs 31, how does the godly woman live this out?
Proverbs 31:26-27 states that a godly woman "opens her mouth with wisdom, and on her tongue is the law of kindness. She watches over the ways of her household." Much of the teaching on Proverbs 31 has focused only on a woman's physical labor and financial prowess, limiting the woman to her many household tasks. However, the word "watches" in this passage (tsaphah) is the same word translated as "watchman" in other places in Scripture (see for example, Ezekiel 3:17). How would this term apply to the godly woman?

The godly woman "seeks wool and flax, and willingly works with her hands (Proverbs 31:13). Wool covers from the cold, and sometimes in Scriptur "cold" is symbolic of God's judgment against sin. Thus, we see that "wool and "flax" can cover us from such judgment (see Hosea 2:9). How would this symbolism apply to the godly woman?
The woman's hands mentioned in Proverbs 31:13 are <i>kaph</i> hands, which refers to hands open or upturned, and can refer to hands extended in prayer How do these hands of the godly woman compare to the hands of the evil woman (see Proverbs 7:26)? What work does the evil woman seek to do?
Read Proverbs 31:21. Scarlet wool and hyssop dipped in blood were used in Old Testament ceremonies to cleanse God's people from sin. How does the godly woman cover her household? How does this provide the basis for her confidence?
Proverbs 31:14 states that the godly woman "is like the merchant ships she brings her food from afar." The godly woman imports not only physical food for her family, but also spiritual food. How does the godly woman accomplish this? In what ways can she be likened to a merchant ship bring ing her food from afar?

Proverbs 31:25 states that "strength and honor are [the godly woman's] clothing; she shall rejoice in time to come." The godly woman laughs in derision over the future. What is the basis of the woman's laughter and her confidence in the future?
A SNARE, A FETTER OR A CROWN?
Proverbs 12:4 states, "A virtuous woman is a crown to her husband: but she that maketh ashamed is as rottenness in his bones" (<i>KJV</i>). "Rottenness" means to decay or erode, and "bones" can allude to strength in Scripture. What effect does the evil woman have on her husband?
Notice that the man who has been made ashamed by his wife has not necessarily become a thief, a murderer or a publisher of pornography, but his strength has been eroded so that his potential is never fulfilled. This is not to say that the woman has the responsibility for her husband's life and choices, but she is an extremely significant influence for strength or weakness in his life. The virtuous woman is a "crown" to her husband. In Scripture, crowns relate to wisdom. Read Proverbs 4:8-9. What will the godly woman bring to her husband?
The word "crown" is taken from a word that means "to encircle (for attack or protection)." How does this definition relate to the meaning of the word "helper" in Genesis 2:18?

Proverbs 31:11 says that a man's heart may safely trust in a virtuous woman. In this passage, "heart" can be translated as "understanding." God
has uniquely and specifically designed the woman to influence her hus-
band's understanding more profoundly than any other person in his life.
In doing so, she will bring him honor-a "crown." The influence of the
godly woman will be felt in the man's life far outside the four walls of his
home and their own intimate relationship. Read Proverbs 31:23. What is
the ripple effect of the woman's influence in her husband's life?
Considering the amount of the Control
Considering the awesome place that God has given to women, how do you think Satan responds to her?
think Satan responds to her?
16000
A Closer Look at My Own Heart
As we have discovered, Scripture has much to say about the immense value and the incredible role that God intends women to play in His design for man, for family and, ultimately, for society. We will examine her role as a prayer warrior in the next chapter, but as we conclude this section, we want to focus on the influence of the woman, particularly in marriage. God has fashioned each of us for intimacy, but women particularly so. As such, her influence will be felt in the very depths of her husband's being, in his understanding and in his emotions—for good or for evil.
Women: Are you aware of the extent of the power of influence you exert in
the life of your husband? Why or why not?

Are you willing to leave your safe place, your self-protective ways and become fully present to your husband even if it is uncomfortable for a time? If so, what steps will you take to accomplish this? Where will you find strength to do this?
Will you take the mantle and become the crown to him that God designed you to be? Why is this critical in your relationship with your husband?
Men: Have you received your wife as the help and influence that God intended you to have through her? Or have you been keeping her at a distance, guarding yourself against the very blessing that will help bring wholeness and healing to your life? If so, what will you do to change? Where will you find strength to do this?
Are you willing to leave your safe place, your self-protective ways and become fully present to your wife even if it is uncomfortable for a time? If so what steps will you take to accomplish this?
Will you receive her from God's hand as a precious gift to you? Why is this critical to do in your relationship with your wife?

Perhaps you feel unable to adequately respond to the above heart-searching questions. Perhaps you feel you have lived in your self-protective ways too many years and you don't know how to emerge from your hiding place. However, remember that God has said, "It is not good that the man should be alone; I will make him an help meet [suitable] for him" (Genesis 2:18, *KJV*). Therefore, if you are a woman, you can trust Him to make you the suitable help He promised; and if you are a man, you can trust God to enable you to receive the help that He has made for you.

Action Steps I Can Take Today

Bring your fears of inadequacy to the Lord. Tell Him that you are trusting Him to fulfill His own perfect design in your life.

Talk with your spouse. Share your fears and your doubts and ask him or her to support you in prayer as you make this new commitment before the Lord. Commit to be patient and give each other grace as you learn to walk this new road.

Write down Proverbs 18:22. Ask God to give you a heart revelation of His intent for you as you meditate on this verse throughout the week.

Notes

- 1. Jane Hansen Hoyt with Marie Powers, Fashioned for Intimacy (Ventura, CA: Regal, 1997), p. 100.
- 2. Jack Hayford, general editor, The Spirit-Filled Life Bible (Nashville, TN: Thomas Nelson, 1991), p. 710.
- 3. Marie Powers, Shame, Thief of Intimacy (Edmonds, WA: Aglow International, 1996), p. 26.
- 4. Keith Miller, quoted in Terry Hershey, Go Away, Come Closer (Dallas, TX: Word Publishing, 1990),
- Don Hudson, quoted in Larry Crabb, The Silence of Adam (Grand Rapids, MI: Zondervan Publishing, 1995), p. 184.
- 6. Nancy Groom, Married Without Masks (Colorado Springs, CO: NavPress, 1989), pp. 112-115.
- 7. Ibid
- 8. Herbert Lockyer, All the Women of the Bible (Grand Rapids, MI: Zondervan, nd), p. 270.
- 9. Theological Wordbook of the Old Testament (Chicago: The Moody Bible Institute, 1980), #233.
- 10. Ibid., #1673c.
- 11. Ibid., #1608a.
- 12. Ibid., #1071a.

THE WARRIOR WOMAN

And I will put enmity between you and the woman, and between your seed and her Seed; He shall bruise your head, and you shall bruise His heel.

GENESIS 3:15

When God spoke these words, the most devastating and catastrophic event ever to affect humanity had just taken place. The pinnacle of God's creation, man and woman, had just betrayed Him. Surely He would be so angry that He would wipe them out with a breath! Yet right from the beginning, God responded with the same intrinsic quality that He displays over and over again throughout Scripture. He speaks to Adam and Eve of His plans for recovery. Our goal in this chapter is to show how Eve, though she was deceived and beguiled into behavior that was the exact opposite of God's design for her—helping the man toward death rather than life—would ultimately be instrumental in the total demise of her and God's antagonist: Satan himself.

A Closer Look at the Problem

Notice God's immediate response to the situation. What is God's way of dealing with conflict and defeat in our lives?
Genesis 3:15. Even though Satan had been successful in his first strike, in essence what was God telling him in this verse?
Satan had made an inroad by deceiving Eve, and as God pronounces the consequences of this history-altering event, He addresses Satan first. Read

In Psalm 9:15 we read, "In the net which [Satan] hid, [his] own foot is caught." How does this verse illustrate Satan's ensnarement of Eve?
The American Heritage Dictionary defines "enmity" as "deep seated, often mutual hatred." What was God actually saying to Satan concerning the woman
A Closer Look at God's Truth
In his book <i>Destined to Overcome</i> , author Paul Billheimer states that when Adam "transferred his allegiance from God to Satan, he also transferred his dominion." What does this mean in terms of who would now be governing the earth? What would be the result?
God would not leave humanity in their fallen condition forever. What does the second part of Genesis 3:15 tell us about God's plan for recovery?
Heaven and earth's greatest victory would be realized out of this greatest point of defeat. What role would Eve, as a representative of woman in God's design, play in that ultimate victory?

THE AUTHORITY RETURNED

When Jesus, the perfect Seed, came forth through woman and then went down into death, it looked as though Satan had won again. However, Je-

sus' death on the cross was the very act that crushed Satan's head and de-
livered the deathblow to his authority. As God the Son, Jesus was always
in authority over Satan. So, on whose behalf was Jesus acting, and why?
<u> </u>
It is important to note that when Jesus defeated Satan, He did not annihilate him. Given the fact that Satan is still a force in this world, what part do believers play to continue Jesus' work? Why?
THE STRENGTH OF AN ARMY
God has uniquely designed women to enter into His work of recovery in the earth. Throughout the book of Proverbs, the godly woman is referred to as a "virtuous" woman. The word translated as "virtuous" is the Hebrew word <i>chayil</i> , which means "force, whether of men, means, or other resources." What does this tell us about the virtuous woman?
Think of the people in your life. Who is someone you consider virtuous? Is being virtuous innate? Do you think it possible to <i>become</i> a virtuous person? If so, how (see 2 Corinthians 5:21)?
Warring Hands
Proverbs 14:1 states, "The wise woman builds her house [or family], but the foolish [perverse] pulls it down with her hands." What does this verse tell us about the power of a woman's hands?

Two kinds of hands are mentioned in Proverbs 31, both of which the woman uses to build her house. The first are <i>kaph</i> hands, which we previously noted refer to hands that are open or upturned, beseeching God for His grace and mercy on families. The second type of hands are <i>yad</i> hands, which may be "open or closed in a grasp or fist." <i>Yad</i> hands can refer to power, means or direction. What does this tell you about how the woman uses her hands?
Psalm 144:1 states, "[He] trains my hands [yad] for war, and my fingers for battle." The word for fingers (etsba) denotes "grasping, something to seize with." What has the virtuous woman learned to do as it relates to the spiritual realm?
- Andrew Committee Committ
A virtuous woman is one whose heart is turned to God and who has begun to see things from God's perspective. In <i>The Ultimate Intention</i> , DeVern Fromke states, "As believers God is either the center of our universe and we have become rightly adjusted to Him, or we have made ourselves the center and are attempting to make all else orbit around us and for us." How does this relate to the virtuous woman?
The wilderness wandering of the Israelites was symbolic of a people who had been delivered from Satan (Pharaoh) and the world (Egypt) but were still dependent on their self-life. Read Joshua 5:1. When the Israelites prepared to leave the wilderness behind and cross the Jordan River to possess the Promised Land, what was the response of the Canaanites? How does this principle apply to our lives as Christians?

She shall rejoice in Time to Come As we previously noted, Proverbs 31:25 states that the godly woman "shall rejoice in time to come." The word "rejoice" in this sentence can mean to laugh or hold in derision, contempt or scorn. Who is it the woman will hold in contempt or scorn?
Read Genesis 3:13-14. What did God do when Eve chose to make the breach between herself and Satan by exposing him as the deceiver?
Think about some of the ways that Satan has come against women throughout the ages, twisting and distorting her role and her place in God's plan. What do you think Satan fears would happen if women were restored to their rightful position?
EYES TO SEE
Satan's tactics will work only as long as women are blind to their role and the power that God has given them to fulfill it. What happens when a woman becomes "virtuous," or awakened to her womanhood as God intended it from the beginning?
Proverbs 9:10 states, "The fear of the LORD is the beginning of wisdom." The Lord wants us to be wise. Read Ephesians 1:17-23. What does verse 17 tell us is the way we receive the spirit of wisdom and revelation?

The prayer of Paul in these verses is a universal prayer that God would have us pray today. God wants us to ask for the "spirit of wisdom and revelation" that only comes through "the knowledge of Him." What is the result of having "the eyes of [our] understanding" opened?
Read Ephesians 2:5-6. In this passage, Paul declares that we, too, were raised up with Christ by the same power that raised Him and were seated with Him in the same heavenly places. Why is it critical for us to understand this? How does it affect our authority in the spiritual realm?
How would such knowledge affect the virtuous woman and the way it relates to the work of her hands?
Spiritual Reproduction
In what ways has God chosen to write within the nature of women an in- nate desire to nurture life?
Women are also innately designed to participate in the bringing forth of life in the spiritual realm. When God desires to enact His plan on earth, He looks for those who have ears to hear and eyes to see by the Spirit what He wants to do. How does this plan become implanted in their spirit? How does it grow (see 2 Peter 3:18)?

Read Matthew 6:9-10. What has always been God's intent for prayer?
Prayer is implementing <i>God's decisions</i> . It is enforcing <i>God's will</i> on earth. Read Proverbs 31:22. Throughout Scripture, purple robes refer to royalty or to kings' robes. Given this, what does it mean for the godly woman to be clothed in fine linen and purple?
Read John 14:13-14. What is Jesus saying to us about how to pray? What will our prayers do?
Read John 15:7-8 and 16. What condition or requirement does God place on our prayers? Why does God want to answer our prayers?
THE FRUIT OF HER SEED In the Bible, we are often given a physical reality that is symbolic of a spiritual truth. Genesis 3:16, spoken to the woman, is one such example: "I will greatly multiply your sorrow and your conception; in pain you shall bring forth children." Beyond the imagery of the pain of childbirth, what spiritual concept is being symbolized here? In what ways are women called to labor and travail in prayer?

What does this require on the part of the woman?
GIVE HER THE FRUIT OF HER HANDS
The virtuous woman is a warrior woman. She allows God to teach her
hands to engage in war and her fingers to fight. She takes her stand against
God's enemy, Satan, and refuses to back down until she sees total victory
We see an example of this in the story of the persistent widow in Luke 18:1-
8. How does this parable relate to the virtuous woman?
Proverbs 31:31 is the final pronouncement upon the virtuous woman
What are we told is her reward?

A Closer Look at My Own Heart

Although our attention has been specifically focused on women in this chapter, the Hebrew word *chayil* refers to both men and women. When the word is used to refer to men, they are described as "warriors." When the word is applied to women, it is translated "virtuous." Men and women alike are called to this kind of life-giving, warring and interceding prayer that will bring forth life in the kingdom of God. Although prayer involves work, it is not a burden but a great privilege that we have been given by God.

Think about what has been your heart perception of prayer. Has it been that of a beggar—one who approaches a reluctant God, appealing to His mercy in the hopes of getting a few crumbs? Or one who, by some chance miracle, might hit on the "right" formula to get a response? Perhaps you

How has the material in this session affected your understanding of prayer?			
you—your will, your goodness, and your worthiness to ask? What was perception of prayer before doing this study?			
have thought prayer is about getting God to agree with you about who needed in a given situation. In other words, has prayer been only ab			

Action Steps I Can Take Today

As a Christian abiding in Christ, you can begin to count on the fact that if something concerns you, it does so because it concerns God. He has likely planted that concern in your heart and is stirring you to action—to prayer.

Take the concerns of your heart to God with a new confidence, knowing that He has called you for this very purpose. He wants to glorify and manifest Himself through His answers to your prayers. He wants to bring His kingdom to the earth through you.

Write down and meditate on John 15:7-8 as your source of confidence this week.

Notes

- The American Heritage Dictionary of the English Language, third edition (Boston, MA: Houghton Mifflin Co., 1992).
- 2. Paul Billheimer, Destined to Overcome (Minneapolis, MN: Bethany House, 1982), p. 24.
- 3. James Strong, Strong's Exhaustive Concordance of the Bible (Grand Rapids, MI: Baker Book House, 1984), Hebrew #2427.
- R. Laird Harris, Gleason L. Archer Jr., and Bruce K. Waltke, Theological Wordbook of the Old Testament (Chicago: Moody Press, 1980), #1022a.
- 5. Strong, Strong's Exhaustive Concordance of the Bible, #676.
- 6. DeVern Fromke, The Ultimate Intention (Cloverdale, IN: Sure Foundation, 1963), p. 10.

HGOD OF PURPOSE

I know that You can do everything, and that no purpose of Yours can be withheld from You.

JOB 42:2

God is a God of purpose. From Genesis to Revelation, we see that He has had one thing in mind: to gain a people for Himself who would intimately know Him and, out of that personal knowledge, express His image and nature in the earth through His life and power. Everything from beginning to end God has caused to work "after the counsel of His will . . . that we . . . should be to the praise of His glory" (Ephesians 1:11-12, NASB).

The journey to accomplish this has been a lengthy one (at least from our human viewpoint), and the Bible is replete with story after story weaving together many events that tell us how God has gone about the process of fulfilling His purpose. Men and women alike were used at critical junctures in history that forever affected the course of God's plan. In this chapter, we will examine a few of those stories to see how God has enacted His purpose in this earth.

PART ONE: WOMEN OF PURPOSE

Most of us assume that God can and will use men as He works out His will in the earth. When we think of biblical heroes, men such as Joseph, David, Gideon, Samson and Daniel quickly spring to mind. We are less likely to think of Deborah, Rahab, Ruth, Esther and Mary, the great women of the Bible. However, if we are to be reconciled, male and female, we must have a new understanding of the value of each. Our goal in this first section is to determine that God is always working everything together for His distinct purpose and also to affirm how specifically and strategically He has used women throughout history in the furtherance of that purpose.

A Closer Look at the Problem

The story of Job vividly demonstrates the truth of our first goal. Job knew about God and how He wanted him to behave—righteously—and he was obedient to God. He was a generous man who gave to the poor and shunned evil. Like the apostle Paul, Job was "blameless" concerning the law—he was righteous in his behavior. Both Job and his "friends" thought that Job's behavior was the most important thing to God. Thus, when trials and tribulation came Job's way, the first thought that sprang to their minds as to why Job was suffering was based on his behavior—whether or not he had sinned. Job's friends were convinced that he had, but Job consistently responded with protestations of his good works and innocence of evil.

Read Job 13:3,15-16. Even though Job asserts that his hope is in God, w		
do his words tell us that he is depending on to justify himself before God		
The essence of Job's argument was that if he could just get an audience with		
God, he would tell Him how good he had been, and then God would lift		
that trial from him. "My ways will be my salvation," Job proclaims (Job		
13:15-16, NASB). Even though Job declared that he trusted God, his words		
revealed that he believed his own good behavior would commend him to		
God's grace. After a lengthy, distressing and painful testing of his faith, Job		
came to a new understanding of God (see Job 42:1-6). In spite of all his own		
confusion-and in spite of all the accusations and continual haranguing of		
his so-called comforters—God's purpose in allowing the trial was fulfilled.		
4 01 X 1 0 1) F 1		

A Closer Look at God's Truth

Job was given his opportunity to talk with God-or rather to listen to Him					
(see Job 38-41). Read Job 42:5. When Job said, "Now my eye sees Yo					
what was he really saying?					

1 1 1 1 1 1 1 1 1 1 1 1 1 1 1 1 1 1 1 1	
What was God's	s ultimate purpose in Job's life?
	trial, he began to see things from God's perspective. There turning of his center and a personal revelation. What was
	rrial, Job could declare, "I know that You can do all things, ought or purpose of Yours can be restrained or thwarted"
). Why was Job able to express this confidence in God?
PEOPLE OF PUI	RPOSE f purpose, and we are a people of purpose. Nothing can hin-
der that purpos or even our seem	se from coming forth—not our confusion, or our ignorance ning inability for a time to cooperate with God. God is greater Il derail His plan. How is this fact played out in our daily lives
der that purpos or even our seem	se from coming forth—not our confusion, or our ignorance ning inability for a time to cooperate with God. God is greater

The Divine Destiny of a Nation God has always worked purposefully in the lives of His people, though sometimes He works so naturally through us that at the time we are not aware something divine is happening. Indira Gandhi once stated, "If you study history you will find that where women have vision that country attained a high position, and where they remained dormant that country slipped back." Do you agree with this statement? Why or why not?
Read Exodus 2:1-10. Moses was the most illustrious deliverer of all time in the minds of the Jewish people, yet he did not arrive on the scene of Israel's cruel time of slavery and bondage by himself. Three women played key roles in Moses' life. Who were these women, and how were they related to Moses?
In what way was Jochabed, the mother of Moses, a mighty woman of God, a woman of faith, and a "virtuous" woman in the truest sense of the word?
THE FEARLESS FAITH OF A WOMAN Read Hebrews 11:23. Why did Moses' parents make the decision to hide the child? How were they courageous? How did they exhibit faith?
Imagine the day that Jochebed placed Moses in that basket among the reeds in the river, knowing the reality of the situation. What were some of the dangers that Jochebed's baby most likely faced that day?

God Himself orchestrated the events, yet each of the women who responded that day—Jochebed, Moses' sister and Pharaoh's daughter—did so out of the naturalness of her heart as a woman. How did each woman's response relate to her nature as a woman?
The response of these three women resulted in God's plan moving one step forward. Because of the faith and trust of Jochebed and Miriam, and even the unwitting response of the heart of Pharaoh's daughter, God was able to use them in an ordinary, yet clear and strategic way. What does this story tell us about God's ability to fulfill His purpose in our own lives?
WHAT IS IN YOU? Read the story of Hannah in 1 Samuel 1. Note that verse 5 simply states of Hannah that "the LORD had shut up her womb" (<i>KJV</i>). What was Hannah's emotional state over her condition?
How do you think the enemy took advantage of her vulnerable condition? What can we learn from Hannah's story about how Satan works in our lives?
It is important to recognize that God was in the midst of Hannah's barrenness. He was orchestrating something from heaven for the furtherance of His plan and purposes on earth. According to 1 Samuel 1:11, what happened to Hannah before God answered her prayer?

Hannah's petition was granted, and the purpose of God moved another step forward. What does Hannah's story teach us about the burdens in our own lives and the way in which God works?
A WOMAN OF UNDERSTANDING Read 1 Samuel 25. Notice that the first thing Scripture tells us about Abigail is that she was a "woman of good understanding" (verse 3). Abigail had a difficult marriage. She was married to a man named Nabal, whose name literally means "fool" (see verse 25). How does this passage describe what Nabal was like? What kind of life did Abigail have with him?
As the story relates, a potentially deadly situation had arisen in Nabal and Abigail's lives. Nabal, in his typical arrogant way, refused to respond to David's request for food for his men, even though those men had protected Nabal's men and flocks from marauders in the fields. David was angry and threatened to obliterate every man under Nabal's authority. One of Nabal's servants beseeched Abigail to respond to the crisis. How did Abigail respond, and what was the heart attitude of her response?
From this we see Abigail had learned some things out of her need and affliction. What had Abigail allowed God to do in her life in the midst of her pain?
God sent Abigail to influence David at a critical juncture in his life. David's eternal throne and the ongoing purposes of God on earth were forever affected by her action. Through a woman, the plan of God had taken another step forward.

THROUGH WISDOM A HOUSE IS BUILT Proverbs 24:3 states, "Through skillful and godly Wisdom is a house (a life, a home, a family) built, and by understanding it is established [on a sound and good foundation]" (<i>AMP</i>). How does Abigail's behavior give us a picture of what God has in His heart for women?
Read Genesis 21:8-12. How did Sarah affect the history of God's people through her words and behavior? How did she speak into Abraham's life?
Read Esther 4:12-16 and 8:3-8. How did Esther affect the history of God's people through her words and behavior?
Jesus came to change this perception. He came to die for the sin of humanity—sin that caused separation, guarded self-protectiveness and hostility—in a world in which the weak were vulnerable to the strong. Read Joel 2:28-29 and Galatians 3:28. What do these verses tell us is God's intent for the functioning of both our "individual" houses and the House of the Lord?
What is the strength of the Church (see 1 Corinthians 12:4-11)? Why?

A Closer Look at My Own Heart

A key element of purpose is the turning of our focus so that we see life from God's perspective—in other words, what He wants to accomplish in and through us for His own sake. One of His purposes is to restore respect between men and women in His Church, bringing unity and thereby strengthening His people for the work He has given them to do.

Today, examine your own heart before the Lord. Whether you are male or female, what has been your thinking regarding women in the family, the Church and the nation?

Action Steps I Can Take Today

Ask someone to pray with you regarding your response to the above question in the "A Closer Look at My Own Heart" section. If there are attitudes that you need to change, ask God to give you a revelation by His Holy Spirit so that you can be changed from within.

If you have strong attitudes of respect and inclusion concerning the value of women, ask God to strengthen you even more and show you how to communicate those attitudes to the Church. Write down and memorize Job 42:2 as your encouragement concerning this issue.

PART TWO: MEN OF PURPOSE

In the previous section, we noted that if men and women are to be reconciled, they must have a new understanding of the value of each other. Our focus was to show how God, throughout the ages, has strategically and specifically worked through women at critical junctures in history for the furtherance of His purpose. Our goal in this section is to affirm how men are equally essential to God's unfolding plan, how their place has never been more under attack than it is today, and how the presence of women in men's lives helps equip them to fulfill their role in the family, the Church and society.

A Closer Look at the Problem

In his book *Straight Talk to Men and Their Wives*, Dr. James Dobson states, "The western world stands at a great crossroads in its history. Our very survival as a people will depend on the presence or absence of masculine leadership in millions of homes. . . . No modern society can exceed the stability

of its individual family units, and women seem more aware of this fact than their husbands." Why does Dr. Dobson place such a critical importance on the involvement of men in determining the survival of a culture?
FATHERHOOD—CENTER STAGE In Malachi 4:5, God says through the prophet of old that before the "great and dreadful day of the Lord"—before the return of Jesus and the final judgment of God—the hearts of fathers and children will be turned to each other. In Luke 1:17, we find this message repeated when it says of John, "He will go before Him [Jesus] in the spirit and power of Elijah, 'to turn the hearts of the fathers to the children.'" What is the purpose for this turning?
David Blankenhorn, in his book <i>Fatherless America</i> , states, "Fatherlessness is the most harmful demographic trend of this generation. It is the leading cause of declining child wellbeing in our society. It is also the engine driving our most urgent social problems, from crime to adolescent pregnancy to child sexual abuse to domestic violence against women." Do you agree or disagree with this statement? Why?
THE EROSION OF MORAL AND ETHICAL IDEALS The cost of fatherlessness to us as a society has been so immense that it defies adequate description. No part of our lives has remained unaffected. The Russian novelist and historian Aleksandr Solzhenitsyn once noted, "The west has been undergoing an erosion and obscuring of high moral and ethical ideas. The spiritual axis of life has grown dim." What things have happened in our society in this regard to cause the erosion and decay?

In what way is our cultural decline a symptom of our spiritual decline?
The Enemy Comes in Like a Flood In the mid-1950s, radicals, intellectuals and freethinkers from university campuses across America began to voice that message that "God is dead." What were they actually saying by this? What did this indicate about their moral condition and what they felt they could ethically do or not do?
What was the effect of the words of these radicals and freethinkers on American culture?
During this same time frame, God began to raise up another voice on earth: Billy Graham. His message was simple, yet extremely profound: "God loves you, and He has a purpose for your life. Repent, and your sins will be forgiven." Through his ministry, thousands of people turned to God. How was his message the polar opposite of the radicals and freethinkers?
With the advent of television in the mid-1950s, the media was now able to enter people's homes and influence their minds. How do you think society was affected as people unwittingly allowed themselves to become receptacles of liberal and ungodly rhetoric spread through the media?

How has the Church been affected by this invasion?			
RADICAL SECULAR FEMINISM			
During the 1960s, a counter-cultural revolution took place that emphasized total and utter rebellion against anything of the "establishment." By the dawning of the 1970s, the sexual revolution was in full swing. With it came another expression of dissidence: the radical secular feminist camp. Robert Bork, an American legal scholar, once noted, "Radical feminism is the most destructive and fanatical movement to come down to us from the sixties It is deeply antagonistic to traditional western culture and proposes the complete restructuring of society, morality and human nature." Do you agree or disagree with this statement? Why?			
Were any of the issues that the radical feminists raised legitimate? Why or why not?			
Although the feminist agenda addressed legitimate inequalities, time and investigation have revealed that it contained hidden motives that struck at the heart and harmony of family life as it was defined in the past. Feminism strikes at the foundation of society—it attacks the very heart of God's plan for man and woman and, ultimately, the Church. What is one of the goals of radical reminists as it relates to men? Does it promote a philosophy in which men and women can work together? Why or why not?			

With the feminist agenda, there was not only a dismantling of femininity, but also of gender itself. Such artificial separating of the sexes to live independently of one another struck right at the heart of God's plan. What can we conclude about the source of this agenda?
THE FLIGHT OF FATHERS In Fashioned for Intimacy, Jane states, "The flight of fathers from the home
has come hard on the heels of the feminist agenda I believe that the reaction of women, in large part, has been because of the failure of men to take their proper place in the family and society." What factors have worked together to cause the flight of fathers from the home?
The answer to the ever-widening disparity between men and women and the resulting moral and spiritual problems is that the Church must become what it was called to be: a demonstration to the world of the heart of God. Read Isaiah 60:2-3. How does God intend the Church to make a difference in today's fragmented society?
Read Matthew 5:16. What does Jesus say in this passage about how we are to be seen by this world?

THE FATHER HEART OF GOD

One of the themes we have examined in this study is that God is first of all a Father. Everything He is, everything He says and everything He does flows out of His Father heart. He longs to share Himself and demonstrate His Father heart—a heart of tender mercy and compassion—along with

His strength and leadership. Jesus repeatedly said that He had come to "show us the Father"; that in knowing Him, we would become like Him (see 2 Corinthians 3:18). Earthly fathers were to express their heavenly Father to their families. Sadly, this has not always been the case.

Many earthly fathers have not expressed godly love to their families. What
has been the impact on children who were raised in families in which the
father was disinterested, distant, uncaring or abusive? What has this done
to their perception of God as a father?

A Closer Look at God's Truth

At this point we will revisit the design of woman that we discussed in previous chapters. This truth is critical to the welfare of the family, the Church and the nation, and it will also help us to understand one of the significant ways that God will turn the hearts of fathers today. Although marriage was intended to be a source of blessing and satisfaction, from the beginning it was also intended to "remedy" a problem: man's aloneness. God had observed that his condition was not good and that he would be greatly helped by a wife.

In his book Straight Talk to Men and Their W	ives, Dr. James Dobson states,					
"When a man falls in love with a woman, dedicating himself to care t						
her and protect and support her, he suddenly becomes the mainstay of so-						
cial order."5 In what ways does marriage all	ow a man to change his focus					
and natural drives?						
	•					

Women were designed to help resolve the aloneness of men so that they would be more equipped to function in their place in the family, Church and society. The success of God's design will depend on the receptivity of

the man. Read Proverbs 31:11-12. How does marriage benefit the man? In what ways can God use it to bring men to wholeness?			
As the husband is summoned out of his aloneness, his heart becomes enlarged to better know and understand his wife. With this communion comes a greater knowing on at least four levels. The first of these is that he not only comes to know his wife more intimately but also comes into a deeper knowledge of his own heart. However, as Paul Tournier states, "He who would see himself clearly must open up to a confidant freely chosen and worthy of such trust." What must men do to obtain this first level of understanding?			
On a second level, the depth of the man's relationship with God is affected. What does 1 John 4:7-8 reveal about deepening our relationship with God?			
A third level is that as the hearts of men are enlarged to receive and know their wives, their hearts are often opened to emotionally encompass their children as well. When a man feels that it is "safe" to be emotionally vulnerable, what is he then able to provide to others?			
A fourth and final level that occurs to a man who feels safe to be emotionally vulnerable in his own home is that he is able to be a blessing to his church and community. Read 1 Timothy 3:2-5. What is required of a man who wishes to be a leader in his church and community?			

A Closer Look at My Own Heart

Families today, within and without the Church, are suffering immensely from the loss of fathers. In the worst-case scenarios, the fathers are gone altogether. In other cases, the fathers are physically present in the home but relationally absent. For whatever reason, men are suffering great disrespect in the eyes of many women, and their value in the home is seen to be expendable at best or part of the problem at worst. Men themselves are often not cognizant of the great need for their involvement in the home. They often view themselves as unnecessary on many fronts.

Examine your own heart before the Lord. Whether you are male or female what has been your thinking regarding men in the family, the Church and						
the nation?	88	· · · · · · · · · · · · · · · · · · ·	, de jorden fransk			
1.0.1.1.1.1.1.1.1.1.1.1.1.1.1.1.1.1.1.1	STIVAL		The Robinson of Maria			

Action Steps I Can Take Today

As you conclude this chapter, ask someone to pray with you regarding your response to the above question in the "A Closer Look at My Own Heart" section. If there are attitudes you need to change, ask God to give you a revelation by His Holy Spirit so that you are changed from within.

If you have strong attitudes of respect and inclusion concerning the value of men, ask God to strengthen you even more and show you how to communicate those attitudes to the Church.

Notes

- 1. Dr. James Dobson, Straight Talk to Men and Their Wives (Dallas, TX: Word Publishing, 1980), pp. 21-22.
- 2. David Blankenhorn, Futbully, America (Hew York, Dasic Books, 1995), p. 1.
- 3. Robert Bork, Slouching Towards Gomorrah (New York: Regan Books, 1996), p. 2.
- 4. Jane Hansen Hoyt with Marie Powers, Fashioned for Intimacy (Ventura, CA: Regal, 1997), p. 165.
- 5. Dobson, Straight Talk to Men and Their Wives, p. 157.
- Paul Tournier, cited in John Powell, Why Am I Afraid to Tell You Who I Am? (Chicago: Argus Communications, 1969), p. 25.
- 7. Hansen Hoyt with Powers, Fashioned for Intimacy, p. 172.

EIGHT

WILL NOT GO WITHOUT YOU

And Barak said to her, "If you will go with me, then I will go; but if you will not go with me, I will not go!"

JUDGES 4:8

The focus of this study has been about reconciling men and women to God's original design. We began at the beginning, looking at the Father heart of God, who desired a family in which He would dwell by His Spirit and thereby reproduce Himself. His offspring would be in His image, which He declared would be fundamentally manifest in male and female.

Satan, knowing that men and women would have to function together in order for God's image to be expressed in the earth, immediately attacked God's plan at the core. By leading Adam and Eve away from God's life and turning them to their own self-centers (as symbolized in the tree of the knowledge of good and evil), he brought separation, alienation, hostility and shame to that first couple.

That separation is not limited to husbands and wives but affects all relationships everywhere. The Church itself has not yet fully recovered from Satan's great coup.

A Closer Look at the Problem

The goal of this study has not only been to discover God's original design but also to uncover the many ways our self-centers are manifested—the ways they hinder us from the reconciliation and intimacy that would fulfill God's plan for us. In this final chapter, the goal is twofold. The first goal is to again affirm that God indeed has an original design. A second goal is to show that God has been moving in unprecedented ways in these important days to restore His Church to His design so that He might come and fill us with His glory.

A Closer Look at God's Truth

The story of Deborah in the book of Judges profoundly exemplifies the truth of our intended goals in this chapter. As Deborah appears in the annals of Scripture, God's people were again doing "evil in the sight of the LORD" (Judges 4:1). The cause of their evil behavior is summed up in Judges 21:25: "In those days there was no king in Israel; everyone did what was right in his own eyes." As a result, the Lord had sold them into the hand of their enemy, King Jabin, the Canaanite. For 20 years they suffered great oppression, until in their desperation they cried out to the Lord for help.

Read Judges 4:4-24. God sent help to the Israelites by way of a woman named Deborah. What were the several roles that Deborah filled?
What would be the responsibilities of one who was a judge and a prophet
The name "Deborah" literally means "bee," in sense of "orderly motion and "systematic instincts." The Hebrew root of her name is <i>dabar</i> , which means "to put words in order." How would these meanings fit with the design of woman as discussed in previous sessions?
Because of her intimate relationship with God, Deborah was also a military leader who moved with great wisdom and authority. When she heard by the Spirit that it was time to end the oppression of King Jabin, she sum moned a man named Barak. Who was Barak, and what kind of a man walle (see Judges 4:6-7)?

what were Barak's reservations about Deborah's request? What happened as a result (see verses 8-9)?
What was the result of the battle they fought together (see verses 15-16)?
What was more important to Barak: success or maintaining his reputation? What in this story indicates this is the case?
On Sons and Daughters Read Joel 2:28-29. What experience does each group of people mentioned in this passage share?
What was the most radical part of this prophecy for the male-dominated Jewish culture of the time?
Although we have made great strides in mending the breach between denominations and races, a divide still exists between men and women. However, God is moving us forward into a new day. He is moving to reconcile

A Woman Set Free from Bondage

Before women could fully move into their designed place, years of demoralizing hurt, discrimination and disrespect needed to be healed. One

us not only as a corporate Church and as couples but also as individuals.

woman in Scripture who vividly exemplifies the condition of women down through the centuries was the bent-over woman in the Gospel of Luke. Review her story in Luke 13:10-16. What was this woman's condition? How would it have affected her functioning?
Who are we told is responsible for her crippled condition?
Jesus came to earth to "destroy the works of the devil" (1 John 3:8). What were His words to this woman? What effect did those words have on her?
Who was the most indignant about the woman's healing? What reason did Jesus give for His actions?
The Man and American
The Heart of the Issue The story of the bent-over woman reveals the deep work of healing that God has been doing in the heart of women. Incapable of raising them- selves, God, by His Spirit, has been awakening and reconciling them to their womanhood as He intended it to be. It is imperative that this recon- ciliation first occurs within a woman's own heart and spirit. Once this healing occurs, how can she then be free to help others?
MINISTER CONTRACTOR OF THE CON

The restoration that God desires for women is not about positions on church boards. We can (and do) have women in these positions. Today, as

in the Early Church, we have women such as Junia, who was named among the apostles (see Romans 16:7); Phoebe, a deacon (see Romans 16:1-2); and Priscilla, a teacher (see Acts 18:24-26). What is the real restoration that
God is seeking as it relates to men and women in the Church?
Call for the Mourning Women Read Jeremiah 9:13-21. God had sent the people a mourning prophet (Jeremiah), but now He was calling for the mourning women. What were the issues that God wanted to bring to the people's attention?
How would you relate this passage to life as it is today? What are the issues that we are facing for which God has again called forth "mourning women"?
For many women, the great substance of their prayers has been for their husbands, for the fathers of their children. In recent years, we are seeing evidence that God has begun to move and answer those prayers in a mighty way.
AN UNPRECEDENTED MOVE AMONG MEN Review Jeremiah 9:19. Matthew Henry states, "Some make this [verse] to be the song of the mourning women. It is rather an echo to it, returned from those whose affections were moved by their wailings." Those for whom the women were wailing were now responding. What were these individuals now seeing?
Randy Phillips, former president of Promise Keepers, stated, "For years and years the Lord's daughters—our mothers, our wives—have cried out to

God Those tears were seeds that were planted in the ground, and by th mercy of God He is giving hope because He is resurrecting a right heart in His sons." What evidence have you seen in recent years that women's prayer have been heard and men are acknowledging their sin and passivity?
One of the great emphases of recent movements of God among men is return to fatherhood. As Ken R. Canfield says, "It's as if our male cultur were collectively looking at their watches and saying, 'It is five o'clock, tim to go home.' "5 Read Malachi 4:5-6. How does this move among men relat to the fulfillment of this prophecy?
What must be the response of women when God begins this amazing wor of reconciliation among men?
Where the Lord Commands the Blessing The bottom line of everything that Jesus came to do was to restore humankind's relationship with God and with each other. Read 1 John 3:8 What did Jesus come to destroy? What divisions did Jesus come to men and restore?
Pond John 13:31 35. What will happen when our relationships are right-when we are walking in true intimacy with God and others?

The immense mandate of that purpose that God has for His Church cannot be the result of our own self-effort. We need His anointing, His life and His blessing. Read Psalm 133. What are we told brings the anointing, the life and the blessing of God?
What can we conclude will be the state of the Church if we do not respond to this call of God's Spirit for unity at every level?
-
How can we apply Barak's statement, "I will not go without you" (Judges 4:8), to our situation today?

God has a purpose and a design for His family, the Church, through which He desires to fill everything everywhere with Himself. His purpose (and the explanation of His design) is that first and most important, we would know Him. We have been "fashioned for intimacy" for relationship with God. Consequently, our purpose is that we would express His character, nature, authority and power on the earth.

His design is that we be like Him, restored to His image through the working of His own Spirit within us. Inextricable to this design and foundational to everything God wants to do is that we become one. Only together can we represent His complete image, "the church . . . the fullness of Him who fills all in all" (Ephesians 1:22-23). Together we are "Christ," the "one new man" through whom God always intended to express Himself in the earth (see 1 Corinthians 12:12; Ephesians 2:15).

A Closer Look at My Own Heart

Unity in the Church worldwide must begin in our hearts and in the sphere of our own relationships. We must begin with ourselves.

As you conclude this study, ask the Holy Spirit to search your heart. Are there any judgments or strongholds in your life that would be a hindrance to complete reconciliation or the restoration of a true relationship with any segment of the Body of Christ? If so, what are those areas?
Consider your attitudes toward yourself and those of other denomina-
tions, races, cultures and even those of the opposite gender. Is there any
part of Christ's Body—the Church—that you have seen as less valuable than
other parts, or do you see all as equally and vitally necessary to the fulfill-
ment of God's plan for His people?

Action Steps I Can Take Today

If God shows you places of prejudice that are keeping you alienated from other people—even if it is a private, inner alienation—share your insight with at least one other person and ask him or her to pray with you for repentance and a restored attitude.

Pray for each other that your understanding of God's design for you will enlarge and that He will continue to heal you of any hindrances that will prevent you from entering into His full inheritance.

Commit to memory the essence of Barak's short but profound statement as a reminder of God's design for His Body, but particularly as it relates to male and female as the indivisible foundation: "I will not go without you!"

Notes

- Francis Brown, S. R. Driver and Charles A. Briggs, The Brown-Driver-Briggs Hebrew and English Lexicon (Peabody, MA: Hendrickson Publishers, 1996), p. 184b.
- 2. Samuel Prideaux Tregelles, translator, Gesenius Hebrew and Chaldee Lexicon (Grand Rapids, MI: Baker Book House, nd), #1696.
- 3. Matthew Henry, quoted in *The Bethany Parallel Commentary* (Minneapolis, MN: Bethany House, 1985), p. 1542.
- 4. Randy Phillips, "The Power of a Promise Kept," KIRO TV, April 4, 1997.
- 5. Ken R. Canfield, "Lutheran Brotherhood," Bond Publication, Fall 1992.

THE BEAUTY OF INTIMACY LEADER'S GUIDE

The purpose of this leader's guide is to provide those willing to lead a group Bible study with additional material to make the study more effective. Each lesson has one or two exercises designed to increase participation and lead the group members into closer relationship with their heavenly Father.

The exercises are designed to introduce the study and emphasize the theme of the chapter. When two exercises are suggested, it is up to your discretion whether to use them both. In such cases, time will probably be the deciding factor.

If the group is larger than six members, you may want to break into smaller groups for the personal sharing time so that all will have an adequate opportunity to share. As the lessons proceed, the exercises will invite more personal sharing. Keep these two important points in mind:

- 1. Involve each member of the group in the discussion when possible. Some may be too shy or new to the Bible study experience. Be sensitive to their needs and encourage them to answer simple questions that do not require personal information or biblical knowledge. As they get more comfortable in the group, they will probably share more often.
- 2. Make a commitment with the group members that what is shared in the discussion times and prayer requests must be kept in strictest confidence.

After each lesson, be prepared to pray with those who have special needs or concerns. Emphasize the truth of God's Word as you minister to the group members, leading them to a closer relationship with their Lord and Savior.

THE FATHER AND HIS FAMILY

Objective

To help group members understand God's design for the family and how our right relationship with our heavenly Father helps restore the unity of His family, the Church.

Preparation

EXERCISE I

This exercise will work best if you have a diverse group representing a broad span of ages. Obtain a whiteboard, chalkboard or flipchart, felt-tip pens or chalk, and some masking or transparent tape or tacks. Collect descriptions of different sitcoms through the years from the 1950s to the present. Especially note the topics that these sitcoms have addressed and how parents are represented. Choose at least one example for each decade, and then write the title on a sheet of construction paper or poster board. On the back of each sheet, write a brief description of that sitcom.

EXERCISE 2

Obtain a couple of examples of before-and-after pictures of something being restored. This might be of a piece of furniture that has been restored or a person who has successfully completed a weight-loss program or a complete makeover. Mount the pictures on poster board.

DISCUSSION

Familiarize yourself with the questions in the following "Group Participation" section, and choose which questions you want to discuss with the group. Note that there might not be time to discuss every question, so modify or adapt this discussion guide to fit the needs of your group. Additional discussion questions/action steps are provided to stimulate further discussion if you have the time.

Group Participation

EXERCISE I

Display the posters you have made around the meeting room. As you begin the session, invite group members to select one of the sitcoms with which they are most familiar and move to that part of the room. If some groups are too large, invite volunteers to switch to even them out a bit, but even groups are not necessary. Write the following discussion questions on the board or chart and instruct the groups to discuss the questions:

- 1. What was the role of the father/lead male character?
- 2. What was the role of the mother/lead female character?
- 3. How did it represent the family relationships in that decade?
- 4. In what ways was it a true representation of the family in that decade? In what ways was it not?
- 5. How might this sitcom demonstrate the breakdown of the family in our culture?

If there is time, have the whole group come together to discuss question 5.

EXERCISE 2

Display the before-and-after pictures. Invite group members to discuss the work involved in making these restorations. Discuss how these might represent the restorative work that God does when we surrender our lives to Him. Ask how the restorative work of God differs from the work we might do to restore a piece of furniture or our own bodies.

DISCUSSION

- 1. As time allows, discuss the following questions (or the ones you have chosen) from Part One of this week's study:
 - Do you tend to view the term "father" as biological or relational? What constitutes a "father"? What do you think would be most significant to a loving father's heart?
 - What does Ephesians 1:3-6 tell us was God's design for us from before the foundation of the world?
 - According to Hebrews 2:9-10, how has God made every provision for His plan and purpose for us to come to complete fulfillment? What does this tell us about the heart of God for His children?

- What are we told in Luke 2:51-52 that happened to Jesus within the framework of family? What does this say about God's confidence in His design of family?
- At the beginning of time, God clearly spoke out His plan to have a family in His likeness who would represent Him on the earth. Satan also understood this plan, and he launched his attack at the heart of that plan. Who was at the very heart of God's plan, and thus the target of Satan's attack?
- 2. Discuss the following questions (or the ones you have chosen) from Part Two of this week's study:
 - According to Hebrews 4:3 and Revelation 13:8b, when was our deliverance accomplished?
 - How do Isaiah 53:4-5 and Ephesians 2:5-6 affirm that God's purpose in sending Jesus was so that we would receive restoration in every dimension of our lives?
 - What are the character qualities that God declares about Himself in Exodus 34:6-7?
 - According to Matthew 22:36-40 and Romans 13:8, what is the fulfillment of the law?
 - What things does Ephesians 1:11-12 tell us God works according to the counsel of His will? What is the end result of His working? What can we know about the way God moves today based on these verses?

ADDITIONAL DISCUSSION/ACTION STEPS

- 1. Discuss how TV and other media portray fathers in our culture. Point out the evolution of the sitcom view of fathers over the years. How do these skewed portrayals affect the world's view of God, our heavenly Father? What are the results of these negative views?
- 2. Discuss how our relationship, or lack of relationship, with our earthly father can affect our intimacy with our heavenly Father. How do our relationships with others affect our relationship with God?
- 3. Discuss how a restored relationship with God can help us restore our relationships with others.
- 4. Close the session in a time of prayer, inviting those who are in need of a right relationship with God or with others to receive prayer.

TWO

HTALE OF TWO TREES

Objective

To help group members understand that we can choose not to sin and that God's original intention of creating men and women with different natures was that together, in harmony, they reflect the image of God.

Preparation

EXERCISE I

Be prepared to discuss the benefits of memorizing Scripture, especially as it applies to resisting the temptation to sin. If possible, recruit one or two group members who regularly memorize Scripture and ask them to prepare a brief testimony of how memorized verses have helped them resist the urge to sin.

EXERCISE 2

Obtain a whiteboard, chalkboard or flipchart and felt-tip pens or chalk.

DISCUSSION

Familiarize yourself with the questions in the following "Group Participation" section and in the lesson, and choose which questions you definitely want to discuss with the group.

Group Participation

EXERCISE I

Read the account of Satan's temptation of Jesus in the wilderness in Matthew 4:1-11. Discuss Jesus' answers to Satan's temptations, pointing out that Jesus used Scripture to refute Satan's statements. Discuss how memorizing Scripture is a helpful weapon in our spiritual war against Satan and his temptations. Ask for volunteers, or those you have recruited, to tell how they have found that memorizing God's Word has given them

strength to resist temptation or overcome a habitual sin. Encourage group members to memorize at least one Scripture verse each week.

EXERCISE 2

Make a simple chart on the board or flipchart by drawing a horizontal line across the top, and then bisect that line with a perpendicular line down the middle. Write "Men" above the vertical line on the left side of the horizontal line and "Women" on the right side. Invite group members to suggest stereotypical traits of men and the counterpart trait of women. For example, someone might suggest that men are more logical, and the counterpart might be that women are more emotional. Continue until you have six to eight traits listed. Discuss how these opposing traits can work together to reflect the image of God and bring glory to Him. Also discuss how this understanding might help in the relationships between men and women.

DISCUSSION

- 1. Discuss the following questions (or the ones you have chosen) from Part One of this week's study:
 - According to John 6:35,53-58, what can we infer that the tree of life represents? What can we infer that the tree of the knowledge of good and evil represents?
 - God first gave a positive command to Adam to partake of His provision before He gave a negative command to resist evil. How do we see this same pattern in Galatians 5:16, Ephesians 6:10-11 and James 4:7?
 - In Genesis 3:22, we see that Adam would have lived forever had he eaten from the tree of life after he had sinned. What would have happened to him if he had partaken of it before he sinned? What can we conclude was Adam's response to the tree of life? Did he *ever* eat of it?
 - How does James 1:14-15 affirm the truth that self is our greatest enemy?
 - · What was Adam being careless about before he sinned?
 - Before God created Eve, only He and the animals were present in Adam's life. Though Adam had not yet sinned, he was not advancing in the way that he should. He was yet separated. In what way was he "separated" relationally from God?

- 2. Discuss the following questions (or the ones you have chosen) from Part Two of this week's study:
 - To what situation was God speaking when He declared, "It is not good that the man should be alone; I will make him an help meet [suitable] for him" (Genesis 2:18, KJV)? For what would the woman be designed to be a help? What kind of help would solve Adam's leaning toward isolation?
 - According to Genesis 1:27, what was the two-step process of the creation of man?
 - The taking of Adam's bride out of his side was a foreshadowing of another event that was to come. What does Paul say this was in Ephesians 5:29-31? What does this tell us about God's value and perspective on marriage?
 - What happens when a man cleaves to his wife? What characteristics or qualities does a man receive back to himself when he cleaves to his wife?
 - Before the woman is called "woman" in the account of creation in Genesis 2, she is called a "help." What does this word tell us about Adam's condition? What does it tell us about the seriousness of the gift that God was giving to the man?
 - In the Bible, the word for "help" in the Hebrew literally means "to surround and protect." The woman was physically weaker than the man, so this could not refer to physical protection. What other type of help could the woman give?

ADDITIONAL DISCUSSION/ACTION STEPS

- People sometimes say "the devil made me do it" as a way to excuse themselves when they give in to temptation. Or they might say that they "fell into temptation," as though it were out of their control. Discuss the validity of these statements.
- 2. Ask group members if there was anything in this week's study that changed their attitudes about relationships between men and women.
- 3. Choose a meaningful verse from this week's study (such as Genesis 1:27) and encourage group members to memorize it. One way to learn the verse is to write it out on the board or flipchart and then erase or cover a word or two as the group recites it together. Continue erasing words until the entire verse is memorized.

THREE

THE STRIKE

Objective

To help group members understand their enemy's tactics and how to resist his temptations.

Preparation

EXERCISE I

Gather magazines, at least one per group member, and obtain two sheets of poster board, scissors and glue or transparent tape.

EXERCISE 2

Obtain a whiteboard, chalkboard or flipchart and felt-tip pens or chalk.

DISCUSSION

Familiarize yourself with the questions in the following "Group Participation" section and in the lesson, and choose which questions you definitely want to discuss with the group.

Group Participation

EXERCISE I

As the meeting begins, give each group member a magazine. Divide the group into two smaller groups. Instruct one group to find pictures from their magazines that show how men objectify women and the other group to find pictures that illustrate how women objectify men. Give the groups a few minutes to make a collage of their pictures. Discuss their findings.

EXERCISE 2

Read 1 John 2:16 in the *New King James Version*. Write the three forms of temptation as a list on the board or chart. Now read James 1:14-15. Write the three steps listed in this verse on the board or chart. Compare these

verses with the process of how Eve gave into the devil's tempting in Genesis 3:1-6. Discuss what is the ultimate result of giving into temptation. Read James 1:12 and encourage group members to memorize this verse.

DISCUSSION

- 1. Discuss the following questions (or the ones you have chosen) from Part One of this week's study:
 - Why was it so crucial to Satan that he snare Adam and Eve into eating of the tree of the knowledge of good and evil and not the tree of life?
 - Because of Adam and Eve's choices, a new system in the world was established. According to 2 Corinthians 4:4, 1 John 2:15-16 and 5:19 what changed after Adam and Eve sinned?
 - Now that Adam and Eve were living from their self-centers, they would judge everything in life by the immediate effect it had on them. How might this understanding of good and evil as it relates to our own self-centeredness affect the way we view and relate to those of the opposite sex?
 - We have seen that men, instead of serving their wives and receiving them into the intended place in their lives, have sought to use them, objectify them or patronize them. How would this attitude fit into Satan's objective to destroy the effectiveness of women and the health and wellbeing of men?
 - In Genesis 3:16, God, in essence, was saying to Eve, "The desire of your heart is turning away from Me to your husband, and he will rule over you." How will this shift change her relationship with God?
 - How do the things we set our desires on rule us and become our gods? Do these gods reign as an overt action on their part, or is it attitude of our own heart? Who holds the key to dethroning these gods and replacing them with the true God?
- 2. Discuss the following questions (or the ones you have chosen) from Part Two of this week's study:
 - "Being needs" are those needs that relate to one's identity, worth, purpose, security and desire to be loved. In what

- ways have you seen people attempt to meet these needs? Are "being needs" legitimate needs? Why or why not?
- According to Genesis 3:17-19, what was the primary result of Adam's choice to depend on himself instead of God?
- Why is satisfaction found in a wrong source or false god always temporary? How can false gods affect your choices?
- The desire of the woman causes her to look to her husband for her life (her being needs). Because she is looking to her husband for her life, he will "rule" her emotionally. What effect will this have on her when he says something she doesn't like or with which she doesn't agree? How will this prevent her from being the help to her husband as God designed?
- "Adultery" is turning away from one's spouse to have a relationship with another. What is spiritual adultery?
- What does James 4:1-4 tell us happens when our expectations are not met in the way we want? How does this describe the internal struggle that will take place in our hearts?

ADDITIONAL DISCUSSION/ACTION STEPS

- 1. Discuss the differences between viewing our relationships with others as sources of life rather than as resources for life.
- 2. Discuss what items (even "good" items) can become gods to us. Why do we put these gods or idols above God? How can we be enslaved by our possessions, our activities or our desires? How can these enslavers destroy relationships with loved ones in general and with our spouses in particular?
- 3. How does "spiritual adultery" affect the intimacy in relationships?
- 4. Continue to encourage members to memorize Scripture verses as a weapon against temptation. Along with James 1:12, another good verse to memorize is 1 Corinthians 10:13. Close the session in prayer.

FOUR

HIDDEN MAN OF THE HEART

Objective

To help group members to understand what true intimacy is and how to encourage its growth in their relationships.

Preparation

EXERCISE

Find a children's book that briefly tells the story of one of the classic fairy tale princesses. Practice reading it aloud. Also obtain a whiteboard, chalkboard or flipchart and felt-tip pens or chalk.

DISCUSSION

Familiarize yourself with the questions in the following "Group Participation" section and in the lesson, and choose which questions you definitely want to discuss with the group.

Group Participation

EXERCISE

Read the fairy tale aloud. If the story doesn't include the usual ending, conclude with "and they lived happily ever after." Discuss the basic elements of the fairy-tale princess stories, such as a beautiful princess in a difficult situation, a handsome prince who comes to the rescue through terrible odds, a villain, and so forth. Write these elements on the board as group members suggest them. Discuss why fairy-tale princess stories are so popular. What are some fairy tales today's young women believe? What are the sources of these fairy-tale beliefs? Why are these beliefs dangerous to healthy male-female relationships?

Discussion

Discuss the following questions (or the ones that you have chosen) from this session:

- Many task-oriented husbands consider themselves "responsible" because they come home every night and bring home their paycheck. What is wrong with this line of thinking as it relates to a woman's need to connect emotionally and relationally to her husband?
- God has specifically designed women with an inner need to move past the surface in a relationship and get to the heart of things. Why do you think women find it easier to move into the realm of feelings than men?
- Is 1 Peter 3:1 telling us that a woman is not to use any words at all in her relationship with her husband? Given the context, what is this passage telling us?
- According to 1 Peter 3:14 and 1 Peter 3:6, what should be the attitude of anyone—man or woman—who trusts in God in the face of rebuffs, angry responses or suffering?
- What is the difference between rule-oriented submission and relationship-oriented submission?
- How can a woman enrich her husband's life and promote growth in his relationship with God?
- What are strategies men have learned to protect themselves from emotions that would label them "unmanly" or "unmasculine"? What is the cost to men for their self-protectiveness?
- What is the effect of men's tendency to isolate themselves on the home, family, church and nation?

Additional Discussion/Action Steps

- 1. After discussing the lesson, refer to the fairy-tale exercise and invite group members to discuss what they have learned in this week's lesson that can improve their relationships so that they can also say that they lived happily ever after.
- 2. Invite volunteers to suggest ways that they can help their husbands and/or other men in their lives learn to understand their emotions and help them come out of their self-imposed isolation.
- 3. Encourage members to memorize Proverbs 31:30. Close in prayer.

FIVE

MNMASKING THE ACCUSER

Objective

To help members understand the sources and differences between false shame and true shame and how women are to be a crown to their husbands.

Preparation

EXERCISE I

Obtain enough small pieces of paper for each member to have one piece. Also obtain index cards (one for each member) and pens or pencils.

EXERCISE 2

Obtain a whiteboard, chalkboard or flipchart and felt-tip pens or chalk. Draw a simple chart on the board or page with a vertical line down the middle and a horizontal line across the top. Title the left side of the chart "Proverbs 31 Woman" and the right side "Today's Woman."

Discussion

Familiarize yourself with the questions in the following "Group Participation" section and in the lesson, and choose which questions you definitely want to discuss with the group.

Group Participation

EXERCISE I

Give each group member a small piece of paper and an index card and a pen or pencil as they enter the room. Instruct them to write a brief statement on the small piece of paper about what they think God would say about them personally. Ask them to *not* put their names on the slips of paper and hand them in to you.

Read through a few of the statements. You will probably notice that many statements will have a negative note to them. Relate those negative comments to the definition of false shame. Discuss examples of false shame, who our accuser is and what our ultimate goal is. Next, instruct the group members to write on the index card you have given them, in large letters: "GOD LOVES ME." Encourage them to keep the card in their Bibles or in another prominent place where they will see the reminder often. Conclude by tearing up and throwing away the small pieces of paper.

EXERCISE 2

Invite a volunteer to read Proverbs 31:10-31. Invite group members to call out the attributes listed in the Scripture passage as you write them on the board. After most of the traits are listed, instruct group members to translate the Proverbs 31 woman attributes to what it means to today's woman, and then write their suggestions on the right side of the chart. Discuss how these verses make women feel about their roles as wives and mothers. Help them to understand that this is the ideal woman, but encourage them that in reality most women try to do their best in serving their families and others. Emphasize verse 30 as the key to becoming a Proverbs 31 woman.

DISCUSSION

- 1. Discuss the following questions (or the ones you have chosen) from Part One of this week's study:
 - In Genesis 3:1, when the serpent came to Eve and told her that the fruit from the forbidden tree would make her be "like God," what was he implying? What was he saying about how God had provided for her every need?
 - According to Revelation 3:17-18, what will we feel if we are found naked and exposed? Why does God allow us to feel legitimate shame? What is He trying to get us to do?
 - Once we decide we are flawed, unacceptable and defective, what do we do to make up the perceived deficit in our lives?
 - Many of us bring a distorted and defective view of ourselves into our relationships. How would this affect our marriages?
 - What happens to a person who has been offended and has built a fortified hiding around himself or herself? How does "staying safe" hinder what God wants to accomplish in us?

- What happens when our God-centered selves begin to emerge? What might be the effect on those around us?
- 2. Discuss the following questions (or the ones you have chosen) from Part Two of this week's study:
 - · At its core, what is idolatry? Who are we really worshiping?
 - What is harlotry symbolic of in Scripture? What are some ways that even Christian women may indulge in behaviors symbolized as harlotry?
 - In Proverbs 31:11, we are told that a man who has found a godly wife can also safely trust his heart to her. What is the meaning of "safely trust" as relates to marriage?
 - How is the godly woman a safe haven for her husband's heart? How is this lived out in their lives?
 - According to Proverbs 31, how does a godly woman do good to her husband and draw him toward God?
 - · What effect does the evil woman have on her husband?
 - According to Proverbs 31:23, what is the ripple effect of the woman's influence in her husband's life? Considering the awesome place that God has given to women, how do you think Satan responds to her?

ADDITIONAL DISCUSSION/ACTION STEPS

- 1. Discuss the differences between false shame and true shame. What are the sources of both kinds of shame? How can we know the difference?
- 2. Discuss what the result of false shame has on our relationships with God and others. What kinds of defenses do we build around ourselves? How can we tear down those defenses and be more vulnerable?
- 3. Invite members to discuss the imagery of the woman being a crown to the husband. Ask how we can translate that imagery into action. Challenge them to choose one action with which they will honor their spouses during the next week. Be sure to follow up on the results at next week's meeting.
- 4. Close in prayer for members, asking God to help them discern the difference between false shame and true shame. Invite them to pray silently for their freedom from false shame and repentance of those actions that result in true shame.

THE WARRIOR WOMAN

Objective

To help group members understand that women fulfill an important role in the Church and in God's ultimate plan for humankind.

Preparation

EXERCISE

Obtain large sheets of white poster board, enough for one sheet for every three to five members, and colored felt-tip pens or crayons.

Discussion

Familiarize yourself with the questions in the following "Group Participation" section and in the lesson, and choose which questions you definitely want to discuss with the group.

Group Participation

EXERCISE

Read Ephesians 6:10-18. Discuss the different parts of the armor of God and what their purposes are. Invite members to form groups of three to five each. Give each group a sheet of poster board and some of the felt-tip pens or crayons. Instruct the groups to draw what they think a godly warrior woman would need in the way of armor and weapons. Encourage them to refer to the passage in Ephesians for inspiration. Some might say they can't draw, but tell them to just use stick figures and encourage them to make their picture large enough to be seen across the room. After a few minutes, invite the groups to share their masterpieces. Hopefully, they will come up with some fun items as well as the important elements that a warrior woman needs.

Discussion

- 1. Discuss the following questions (or the ones you have chosen) from this session:
 - Even though Satan had been successful in his first strike, in essence what was God telling him in Genesis 3:15? What is God's way of dealing with conflict and defeat in our lives?
 - What does the second part of Genesis 3:15 tell us about God's plan for recovery? What role would Eve, as a representative of woman in God's larger design, play in that ultimate victory?
 - Given the fact that Satan is still a force in this world, what part do believers play to continue Jesus' work? Why?
 - What has the virtuous woman learned to do as it relates to the spiritual realm?
 - In Joshua 5:1, when the Israelites prepared to leave the wilderness behind and cross the Jordan River to possess the Promised Land, what was the response of the Canaanites? How does this principle apply to our lives as Christians?
 - According to Genesis 3:13-14, what did God do when Eve chose to make the breach between herself and Satan by exposing him as the deceiver?
 - What happens when a woman becomes "virtuous," or awakened to her womanhood, as God intended it from the very beginning?
 - When God desires to enact His plan on earth, He looks for those who have ears to hear and eyes to see by the Spirit what He wants to do. How does this plan become implanted in their spirit? How does it grow (see 2 Peter 3:18)?
 - What is Jesus saying to us about how to pray in John 14:13-14? What will our prayers do?
 - Proverbs 31:31 is the final pronouncement upon the virtuous woman. What are we told is her reward?

Additional Discussion/Action Steps

1. Discuss why the Lord made women such an important part of His plan to bring salvation to the world. Discuss the evidence of women who have been used by God to further His kingdom.

- 2. Invite the group members to describe a woman they know who is a warrior for God. Ask them to list the characteristics they observe in these women.
- 3. Discuss some of the battles that godly women must fight. What are their strongest weapons for spiritual battles? Discuss the importance of Scripture memorization and prayer as they fight the good fight.
- 4. Close in prayer, inviting group members to say sentence prayers asking the Lord for strength and wisdom to do battle with their enemy.

SEVEN

HGOD OF PURPOSE

Objective

To help group members understand God's divine purpose for the women and men and how that relates to the relationships between the sexes, especially in families.

Preparation

EXERCISE I

Do a little research of other godly women in the Bible and prepare an index card with the Scripture references that tell each of their stories. Some possible candidates might include Rahab, Deborah, Miriam, Ruth, Naomi, Mary the mother of Jesus, Elizabeth, Mary of Bethany, Lydia and Priscilla. Have enough cards for every four to six members to have one.

EXERCISE 2

If possible, collect examples of how the media fuels the battle of the sexes and distorts relationships between men and women.

DISCUSSION

Familiarize yourself with the questions in the following "Group Participation" section and in the lesson, and choose which questions you definitely want to discuss with the group.

Group Participation

EXERCISE I

Briefly review the stories of the women discussed in this week's study: Jochabed, Hannah, Abigail, Sarah and Esther. Have group members form groups of four to six and distribute the index cards you have prepared. Give each group a few minutes to read each woman's story, and then answer the following questions: (1) What was this woman's situation? (2) How did she

demonstrate her faithfulness to God's purpose? (3) What was the ultimate result of her obedience to God's call?

Bring the group back together and invite them to make conclusions for their own lives regarding God's call and purpose for them.

EXERCISE 2

Display the media examples you have collected. Discuss how the media fuels the battle between the sexes and distorts the roles of men and women. Ask how Christians can combat this influence in our families, our churches and our communities.

DISCUSSION

- 1. Discuss the following questions (or the ones you have chosen) from Part One of this week's study:
 - In Job 13:3,15-16, even though Job asserts his hope is in God, what do his words tell us he is depending on to justify himself? What was God's ultimate purpose in Job's life? Why was Job later able to express his confidence in God?
 - Exodus 2:1-10 relates that three women played key roles in Moses' life. Who were these women, and how were they related to Moses?
 - According to Hebrews 11:23, why did Moses' parents make the decision to hide the child? How were they courageous? How did they exhibit faith?
 - In 1 Samuel 1:5, what was Hannah's emotional state over her condition? How do you think the enemy took advantage of her vulnerable condition? What can we learn from Hannah's story about the way Satan works in our lives?
 - When David threatened to obliterate every man under Nabal's authority, how did Abigail respond? What was the heart attitude of her response? What had Abigail allowed God to do in her life in the midst of her pain?
 - According to Genesis 21:8-12, how did Sarah affect the history of God's people through her words and behavior? How did she speak into Abraham's life?
 - According to Esther 4:12-16 and 8:3-8, how did Esther affect the history of God's people through her behavior?

- 2. Discuss the following questions (or the ones you have chosen) from Part Two of this week's study:
 - In Luke 1:17, an angel of the Lord says of John the Baptist, "He will...go before Him [Jesus] in the spirit and power of Elijah, 'to turn the hearts of the fathers to the children.'" What is the purpose for this turning?
 - In what way is our cultural decline a symptom of our spiritual decline?
 - In the mid-1950s, Billy Graham began to give a simple yet profound message: "God loves you, and He has a purpose for your life. Repent, and your sins will be forgiven." How was his message the opposite of the radicals of the time?
 - What is one of the goals of radical feminists as it relates to men? Does it promote a philosophy in which men and women can work together? Why or why not?
 - What factors have worked together to cause the flight of fathers from the home? How does God intend the Church to make a difference in today's fragmented society?
 - What has been the impact on children who were raised in families in which the father was disinterested, distant, uncaring or abusive? What has this done to their perception of God as a father?
 - According to Proverbs 31:11-12, how does marriage benefit the man? How can God use it to bring men to wholeness?

Additional Discussion/Action Steps

- 1. Discuss how the Church has failed in understanding the purposes of men and women in God's divine plan. Read Joel 2:28-29 and Galatians 3:28. What did Jesus do that should heal relationships? How has the Church improved the treatment of women? What more can be done in this area?
- 2. Discuss how the local church can reflect the light of Jesus for healing male-female relationships in the church and community. Encourage group members to suggest specific actions that can be taken. Challenge them to take one of the suggestions and act on it.
- 3. Close in prayer for the healing of relationships and for believers to reflect the light of Jesus in their community.

EIGHT

FWILL NOT GO WITHOUT YOU

Objective

To help group members understand that God desires unity in His Body, the Church, and that it is through this unity that we can powerfully affect the world around us.

Preparation

EXERCISE I

Obtain index cards and three contrasting colored spools of sewing thread (for example, you might chose red, black and white). Cut the thread into 18-inch lengths, enough for a set of six pieces of thread (two of each color) for every two members in the group. Wind each strand around an index card to keep the threads separate. Read the directions in the Group Participation section and try the exercise first to make sure it will work.

EXERCISE 2

Invite someone—preferably one of the group members—to lead the group in singing two or three praise and worship songs, or obtain a worship CD and a CD player. This will be used at the end of the session. Choose two or three worship songs that sing of unity in God's family.

DISCUSSION

Familiarize yourself with the questions in the following "Group Participation" section and in the lesson, and choose which questions you definitely want to discuss with the group.

Group Participation

EXERCISE I

Instruct members to form pairs. Give each pair an index card with the six strands of thread. Read Ecclesiastes 4:9-12. Instruct one member of each

pair to select one strand of the thread, and then invite the pair to break the thread by pulling on it. (This should be fairly easy for them to break, unless you chose industrial-strength thread!)

Next, instruct the second member of each pair to select two more strands of thread and hold them together at one end. Ask the first member to take the other ends and try to break the two strands. Once again, it should be fairly easy for them to break. Now instruct the pairs to take the three remaining strands and, with each of them holding opposite ends, have them twist the strands together. Invite them to try to break this "cord of three strands." Discuss how this represents the importance of working together in unity. Point out that this is a picture of the strength of a man, a woman and the Lord working together.

DISCUSSION

- 1. Discuss the following questions (or the ones you have chosen) from the session:
 - In Judges 4:4-24, God sent help to the Israelites by way of a woman named Deborah. What were the several roles that Deborah filled? What were her responsibilities?
 - When Deborah heard by the Spirit that it was time to end the oppression of King Jabin, she summoned a man named Barak. Who was Barak, and what kind of a man was he? What was his response to Deborah? What were his reservations about Deborah's request? What happened as a result?
 - What experience does each group of people mentioned in Joel 2:28-29 share? What would have been the most radical part of this prophecy for the male-dominated Jewish culture of the time?
 - What was the woman's condition in the story found in Luke 13:10-16? How would it have affected her functioning? Who was responsible for her condition?
 - Who was the most indignant about the woman's healing?
 What reason did Jesus give for His actions?
 - The restoration that God desires for women is not about positions on church boards. We can (and do) have women in these positions. What is the real restoration that God is seeking as it relates to men and women in the Church?

- In Jeremiah 9:13-21, what were the issues that God wanted to bring to the people's attention? How would you relate this passage to life as it is today? What are the some of the issues that we are facing for which God has again called forth "mourning women"?
- What evidence have you seen in recent years that women's prayers have been heard and men are acknowledging their sin or neglect and passivity?
- According to John 13:34-35, what will happen when our relationships are right—when we are walking in true intimacy with God and others?
- How can we apply Barak's statement, "I will not go without you" (Judges 4:8), to our situation today?

ADDITIONAL DISCUSSION/ACTION STEPS

- 1. Discuss how seeing others as an integral part of God's plan should change our relationships.
- 2. Discuss the significance of Ecclesiastes 4:9-12 in light of this week's study. Invite members to share examples of the power of unity within the Church. Discuss what problems disunity in the Church has caused. How does this tarnish the image of God?

EXERCISE 2

Conclude this Bible study with a time of praise and worship, thanking the Lord for the lessons the participants have learned during this study. Invite group members to share a lesson they have learned about intimacy from this study during the past eight weeks.

MHAT IS AGLOW INTERNATIONAL?

From one nation to 172 worldwide... From one fellowship to more than 4,600... From 100 people to more than 17 million...

Aglow International has experienced phenomenal growth since its inception more than 40 years ago. In 1967, four women from the state of Washington prayed for a way to reach out to other Christian women in simple fellowship, free from denominational boundaries.

The first meeting held in Seattle, Washington, USA, drew more than 100 women to a local hotel. From that modest beginning, Aglow International has become one of the largest intercultural, interdenominational Christian organizations in the world.

Each year, an estimated 17 million people are ministered to through Aglow's local fellowship meetings, Bible studies, support groups, retreats, conferences and various outreaches. From the inner city to the upper echelons, from the next door neighbor to the corporate executive, Aglow seeks to minister to the felt needs of women and men around the world.

Christian women and men find Aglow a "safe place" to grow spiritually and begin to discover and use the gifts, talents and abilities God has given them. Aglow offers excellent leadership training and varied opportunities to develop those leadership skills.

Undergirding the evangelistic thrust of the ministry is an emphasis on prayer, which has led to an active prayer network linking six continents. The vast prayer power available through Aglow women and men around the world is being used by God to influence countless lives in families, communities, cities and nations.

GLOW'S MISSION STATEMENT IS . . .

- To help restore and mobilize women and men around the world
- To promote gender reconciliation in the Body of Christ as God designed
- To amplify awareness of global concerns from a biblical perspective

GLOW'S THREE MANDATES

- 1. To promote gender reconciliation between male and female in the Body of Christ as God designed.
- 2. To answer God's call to minister to the Muslim people, while bringing awareness of the basic theological differences between Islam and Christianity.
- 3. To stand in loving support for Israel and the Jewish people, while helping to bring awareness to the Body of Christ concerning God's plans and purposes for those people He calls the "apple of His eye."

HGLOW MINISTERS IN . . .

Albania, Angola, Anguilla, Antigua, Argentina, Aruba, Australia, Austria, Bahamas, Bahrain, Barbados, Belarus, Belgium, Belize, Benin, Bermuda, Bolivia, Botswana, Brazil, Britain, Bulgaria, Burkina Faso, Cameroon, Canada, Chile, China, Colombia, Congo (Dem. Rep. of), Congo (Rep. of), Costa Rica, Côte d'Ivoire, Cuba, Curação, Czech Republic, Denmark, Djibouti, Dominica, Dominican Republic, Ecuador, Egypt, El Salvador, Equatorial Guinea, Estonia, Ethiopia, Faroe Islands, Fiji, Finland, France, Gabon, the Gambia, Germany, Ghana, Grand Cayman, Greece, Grenada, Guam, Guatemala, Guinea, Guyana, Haiti, Honduras, Hungary, Iceland, India, Indonesia, Ireland, Israel, Jamaica, Japan, Kenya, Korea, Kyrgyzstan, Latvia, Lithuania, Malawi, Malaysia, Mali, Mauritius, Mexico, Mongolia, Mozambique, Myanmar, Nepal, Netherlands, New Zealand, Nicaragua, Niger, Nigeria, Norway, Oman, Pakistan, Panama, Papua New Guinea, Peru, Philippines, Portugal, Puerto Rico, Romania, Russia, Rwanda, Samoa, Samoa (American), Scotland, Senegal, Serbia, Sierra Leone, Singapore, South Africa, Spain, Sri Lanka, St. Kitts, St. Lucia, St. Maartan, St. Vincent, Sudan, Suriname, Sweden, Switzerland, Tajikistan, Tanzania, Thailand, Togo, Tonga, Trinidad/ Tobago, Turks & Caicos Islands, Uganda, Ukraine, United States, Uruguay, Uzbekistan, Venezuela, Vietnam, Virgin Islands (American), Virgin Islands (British), Wales, Yugoslavia, Zambia, Zimbabwe, and other nations.

To find your nearest Aglow Fellowship, call or write us at:

P.O. Box 1749, Edmonds, WA 98020-1749 Phone: 425-775-7282 or 1-800-793-8126 Fax: 425-778-9615 / Email: aglow@aglow.org Website: http://www.aglow.org/